FROM HERE TO THERE

A BOOK OF MAZES
TO WANDER AND EXPLORE

SEAN C. JACKSON

CHRONICLE BOOKS

SAN FRANCISCO

I would like to thank my wife, Heidi, for her encouragement, support, and endless patience during the creation of this book. I would also like to thank Paula Willey for her publishing guidance, Noah Jackson for his graphic production help, Lynn Latona for her artistic advice and wisdom, and Heather Jackson for her editorial suggestions and maze running. This book would not have been possible without the amazing folks at Chronicle: production coordinator Michelle Clair, who magically transformed pixels into the object you're holding, designer Neil Egan, who made everything look beautiful, and my editor, Steve Mockus, whose vision, direction, and enthusiasm for the work brought it all together.

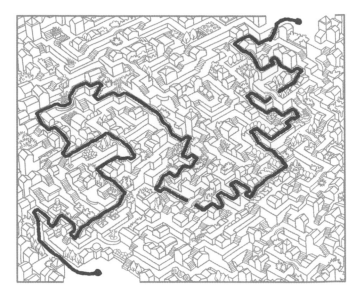

FRONT COVER

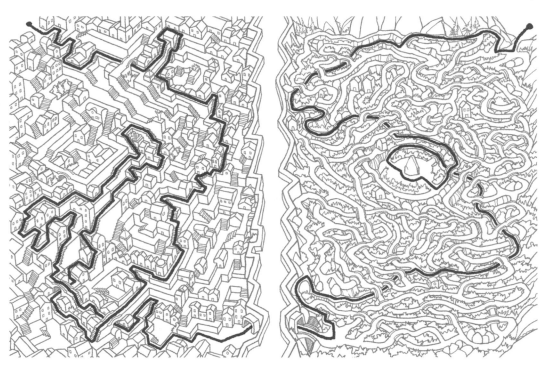

INSIDE COVERS

Manufactured in China

Mazes by Sean C. Jackson
Designed by Neil Egan
Layout & composition by Taylor Roy

10 9 8 7 6 5

Chronicle Books LLC
680 Second Street
San Francisco, CA 94107
www.chroniclebooks.com

INTRODUCTION

I HAVE BEEN DRAWING mazes since I was ten years old. Inspired by Larry Evans' "3-Dimensional Mazes" books in the late seventies, I began to draw landscape, hose, and rectangular perspective pipe mazes as often as I would draw monsters and spaceships. Even then, I enjoyed creating a maze, watching how it developed, and following its paths when finished.

My mazes take cues from the physical world I observe and are influenced by the work of artists I admire. My early fascination with M. C. Escher's artwork inspired me to include surreal architecture and perspective-based illusions, and later, years of drafting class, working construction, and eventually drawing building plans helped inform my interest in the simple beauty of buildings and structures. In art school I fell in love with the work of painters such as Richard Diebenkorn, Susan Rothenberg, and Keith Haring, and found inspiration in the line and color of comics artists such as Frank Miller, Bill Sienkiewicz, and the Hernandez brothers. I was hooked on sculpture and the way it defines space when Richard Serra installed one of his massive steel artworks near my art school in 1984. I also did a great deal of woodblock printing at this time, appreciating the limited palette, flat colors, and strong shapes. My color choices here also reflect my love of the animated films of Hayao Miyazaki, Pixar, and Disney's new golden age.

My mazes are always hand drawn, first loosely sketched out to find the nature and life in them, without real perspective other than a hint here and there. The drawings are doodles that spread across the page, and the maze is the structure they cling to. Living in various cities (Baltimore, Pittsburgh, New York) I took to observing the way buildings fit together, and so I see the mazes growing like a city grows. There is some planning, but also delight in the irregular and unusual spaces that I discover in their creation.

Drawing the mazes is meditative and relaxing for me, as I hope following their paths is for you. For me, making them is contemplative, an automatic meandering, with bursts of inspiration and discovery. Having worked in television news for 25 years—a job I love, but that couldn't really be called *relaxing*—I relish being able to unwind in the world of a maze.

I am constantly going back and re-traveling my mazes. I am always a little surprised when I reach a loop or dead end. The mazes are not constructed to be fiendishly difficult (not too easy, not stressfully hard), and I know I will make my way to the end soon. Occasionally, I will stumble onto the end accidentally and, not knowing how I got there, be compelled to travel it again.

In making the mazes for this book, I have organized a loose flow from easier to more difficult as we go from front to back. Feel free to flip, pick and choose a maze as the mood strikes you with this in mind. Solutions are included in the back of the book according to page numbers, and if you are interested, I've included a few notes on what I had in mind when creating some of the mazes on the last page of the book.

I highly recommend following the paths of the mazes using your finger, or the non-writing end of pencil or pen, used as a stylus. The Larry Evans books that inspired me many years ago offered this advice, which allowed me follow the paths again and again and enjoy them for years. As the creator of theses mazes, I still find delight in revisiting them. I hope you will, too.

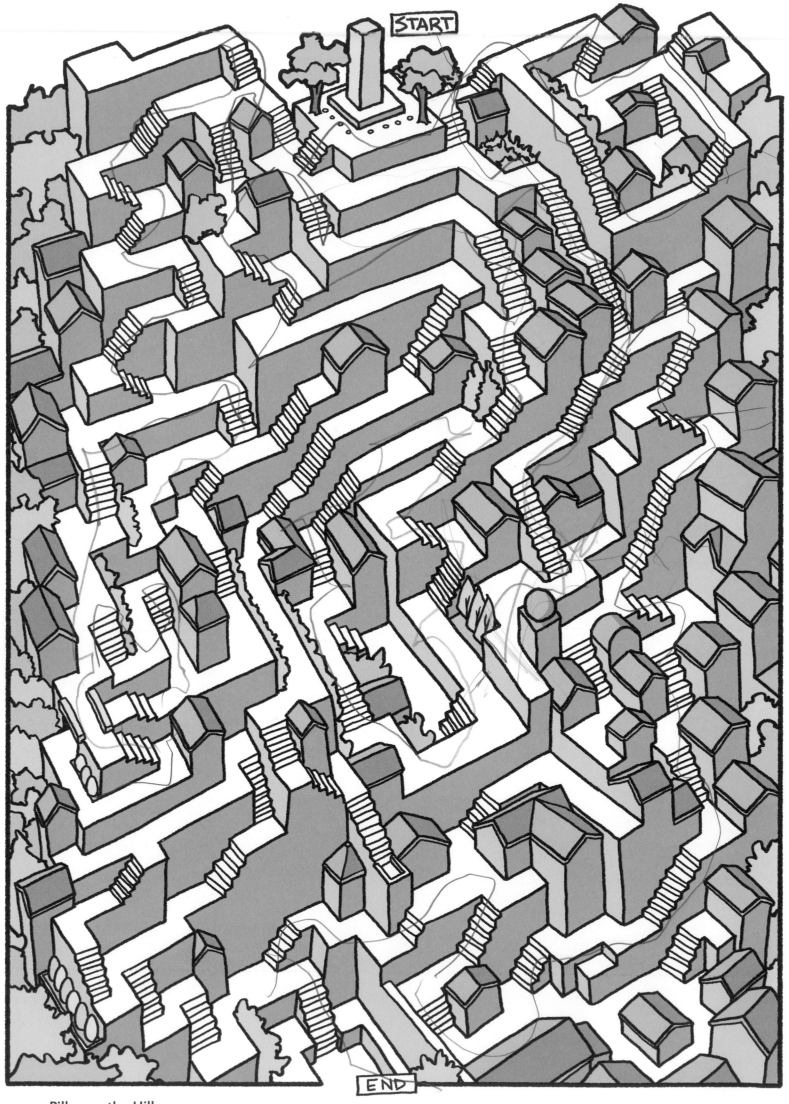

START

END

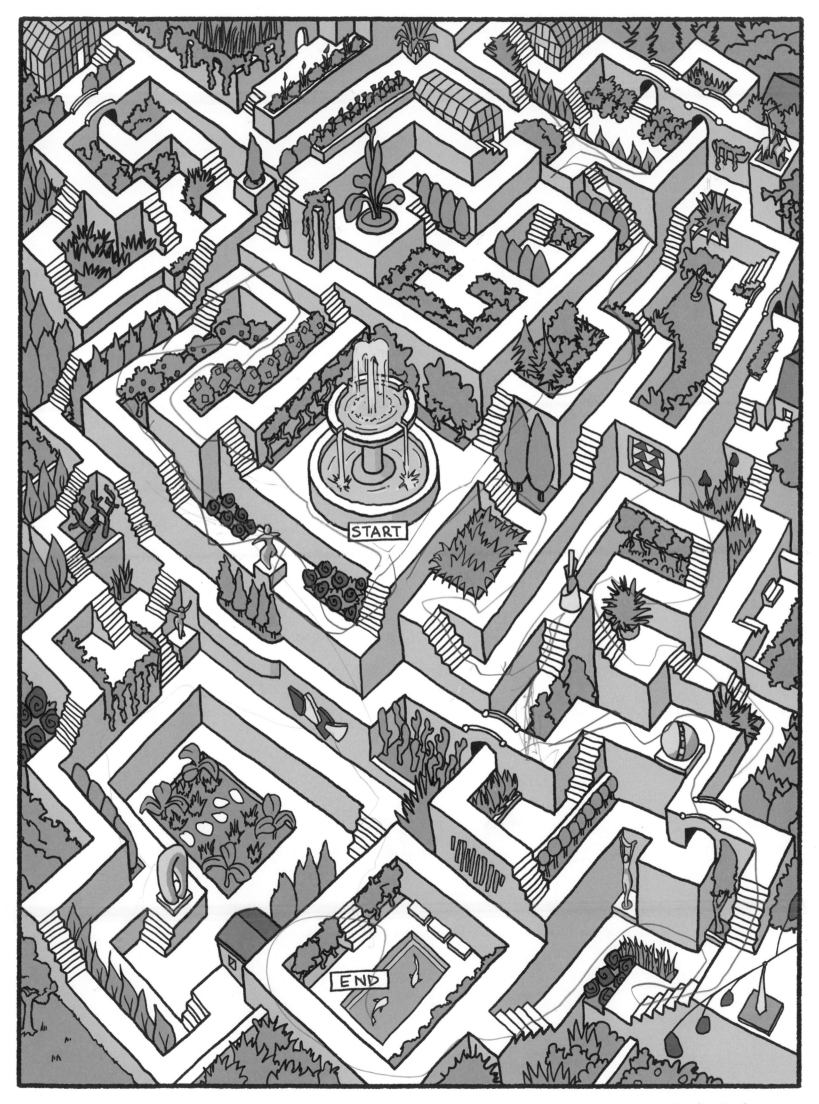

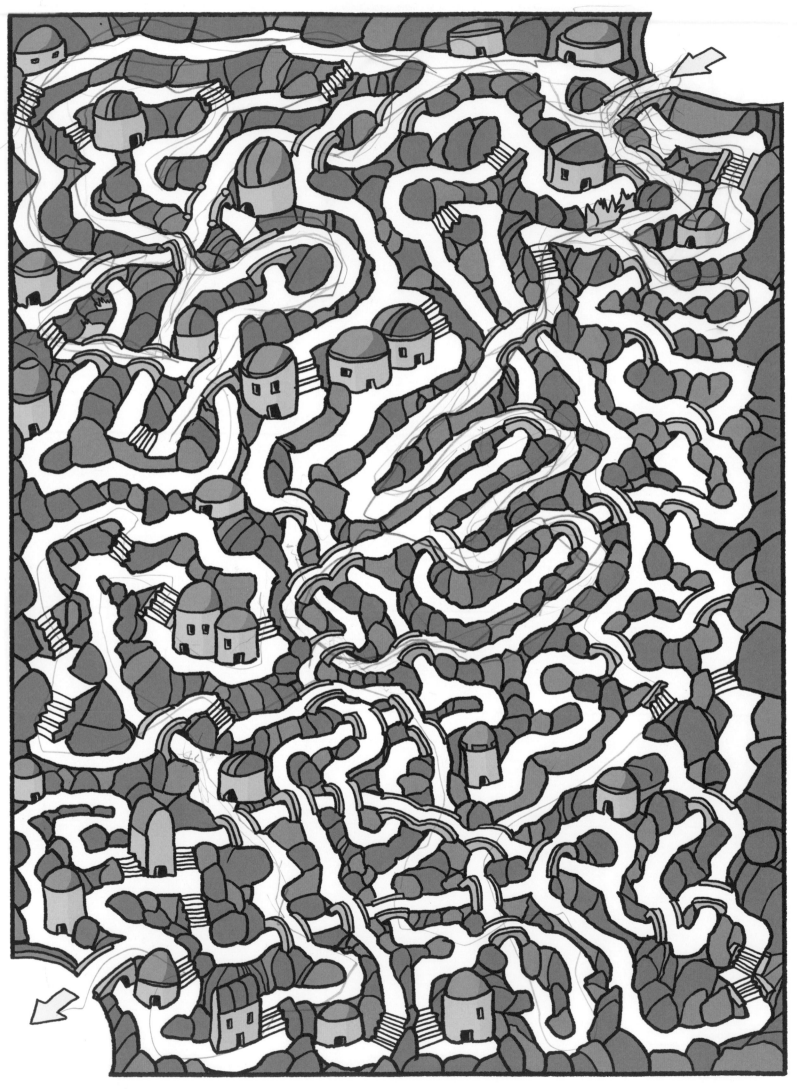

Rocky Road

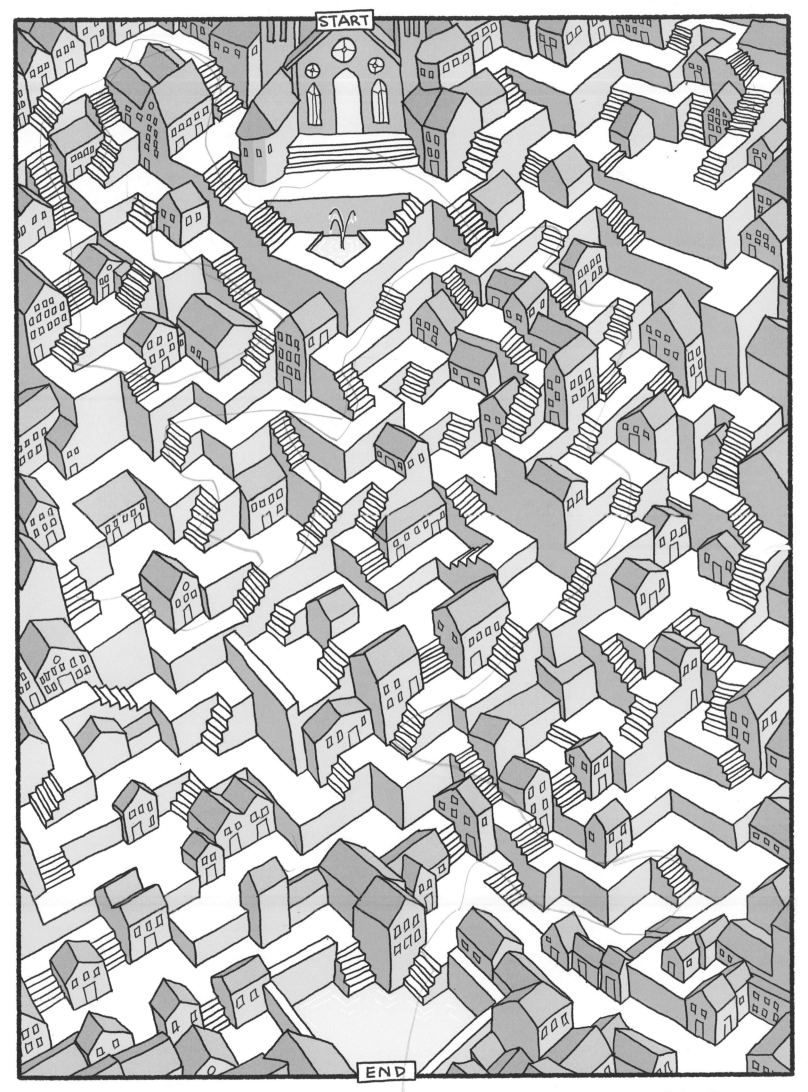

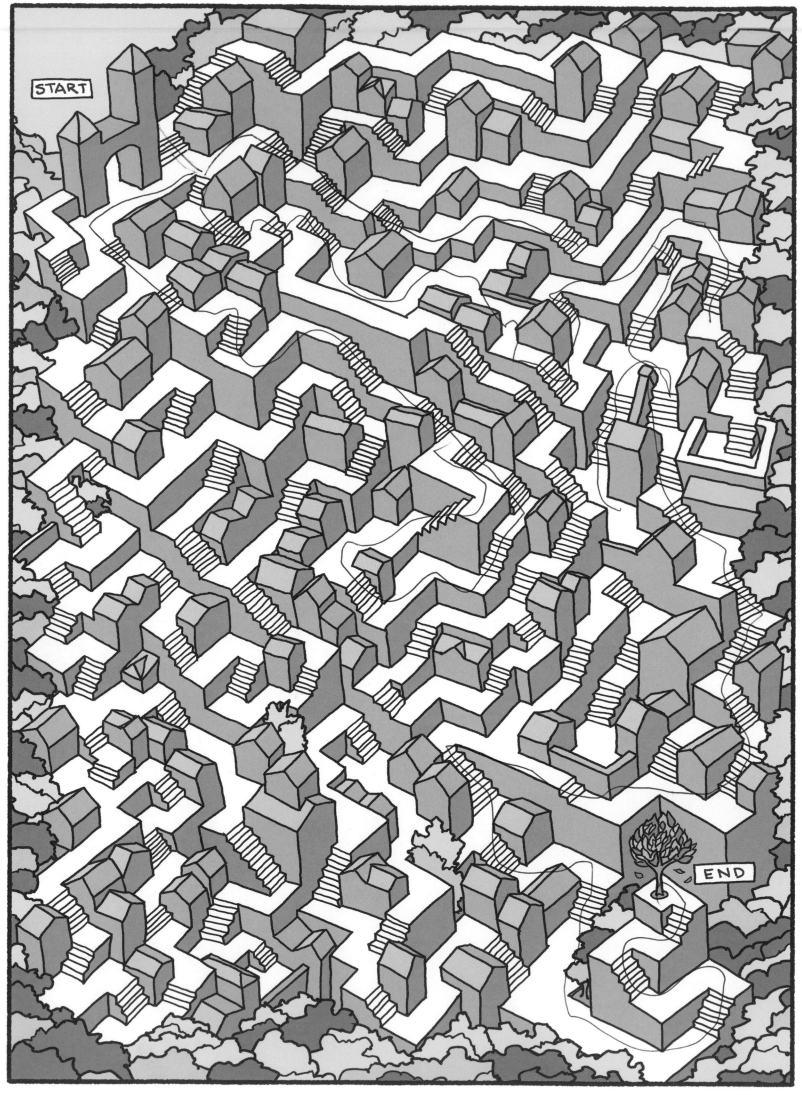

START

END

One Autumn Tree

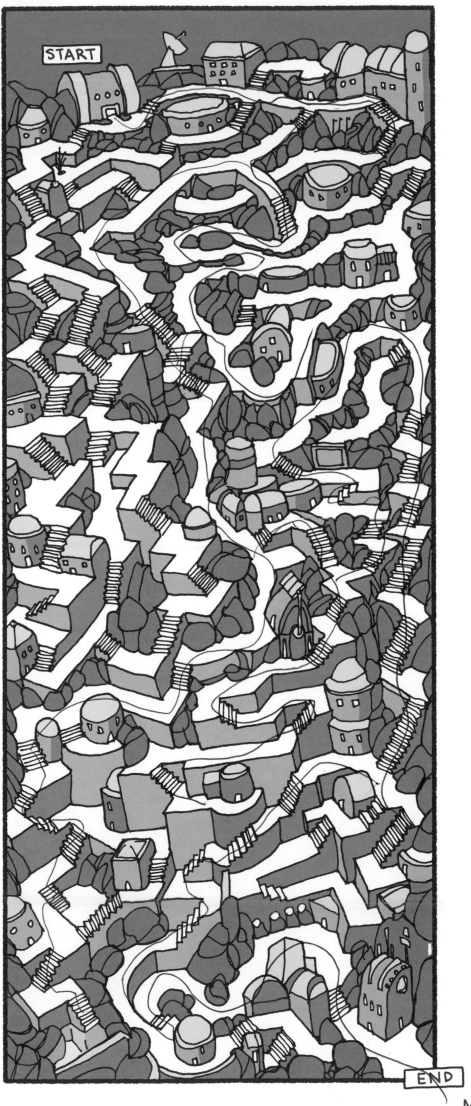

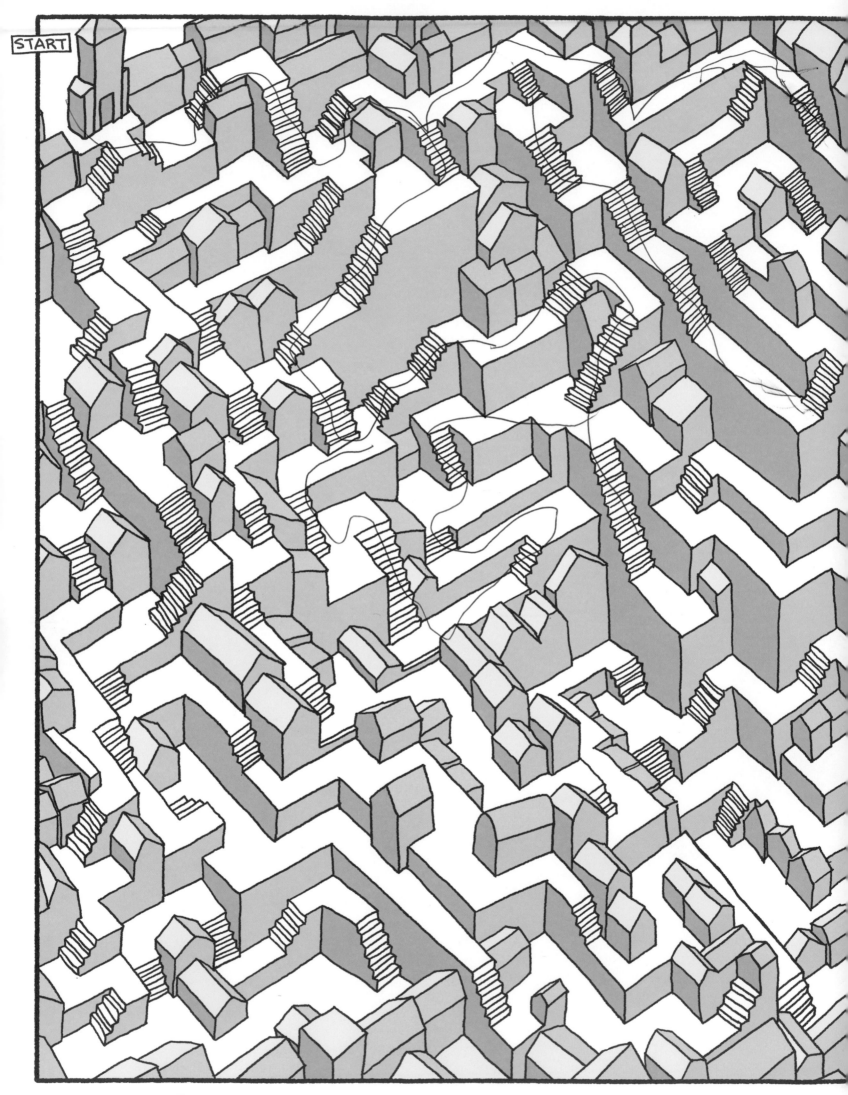

Eye of the Needle

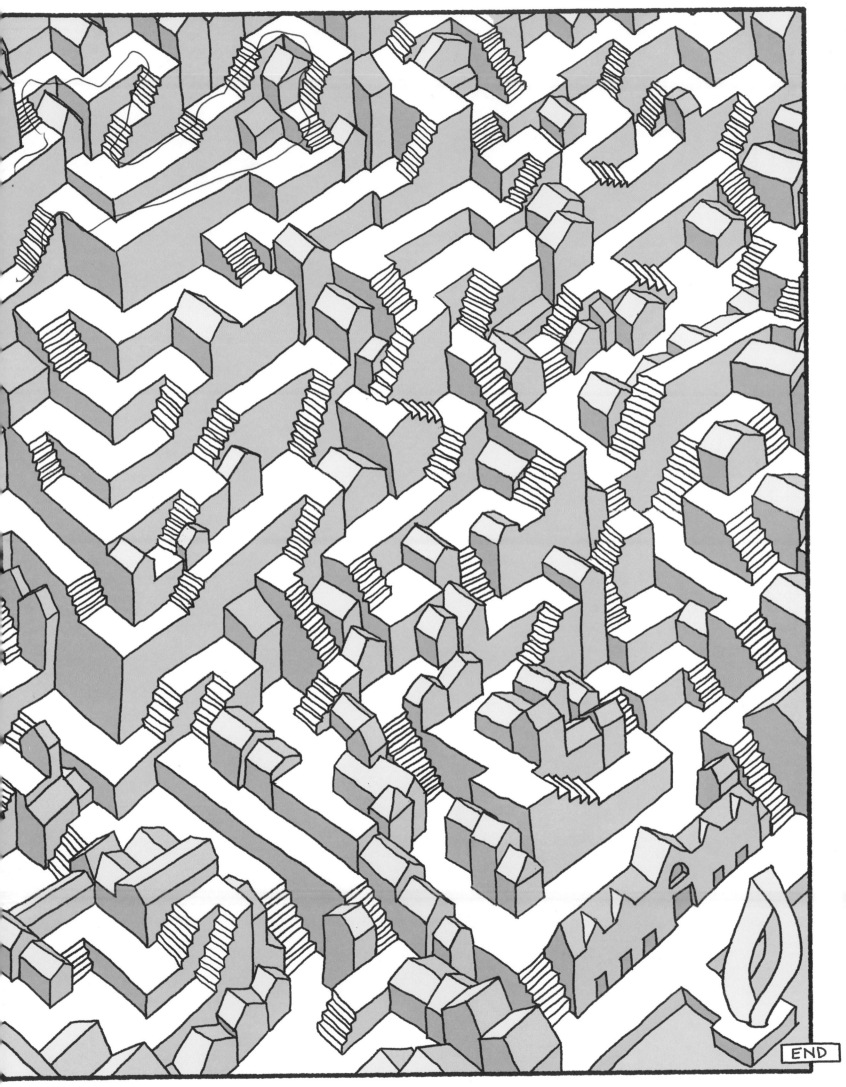

END

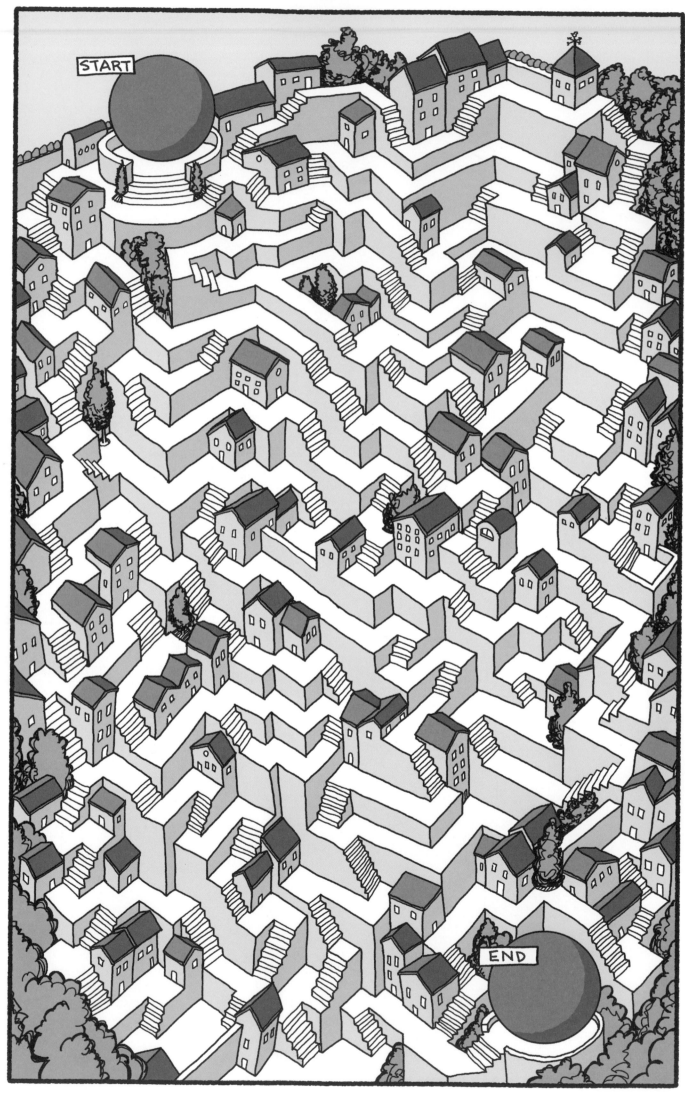

Harmony of the Spheres

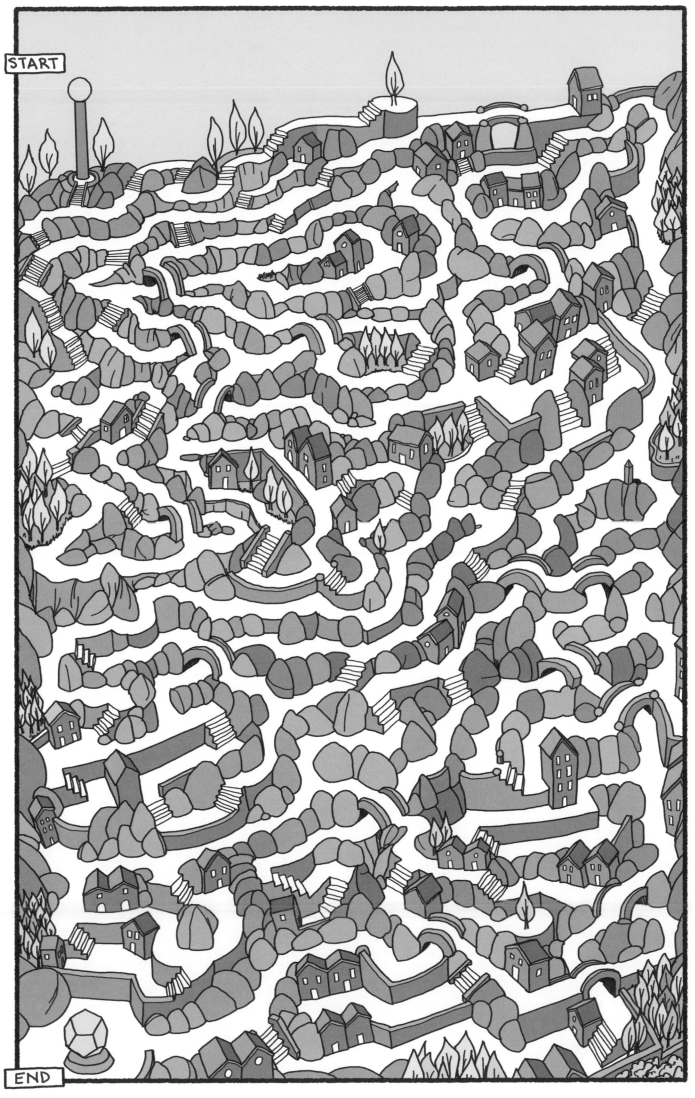

START

END

START

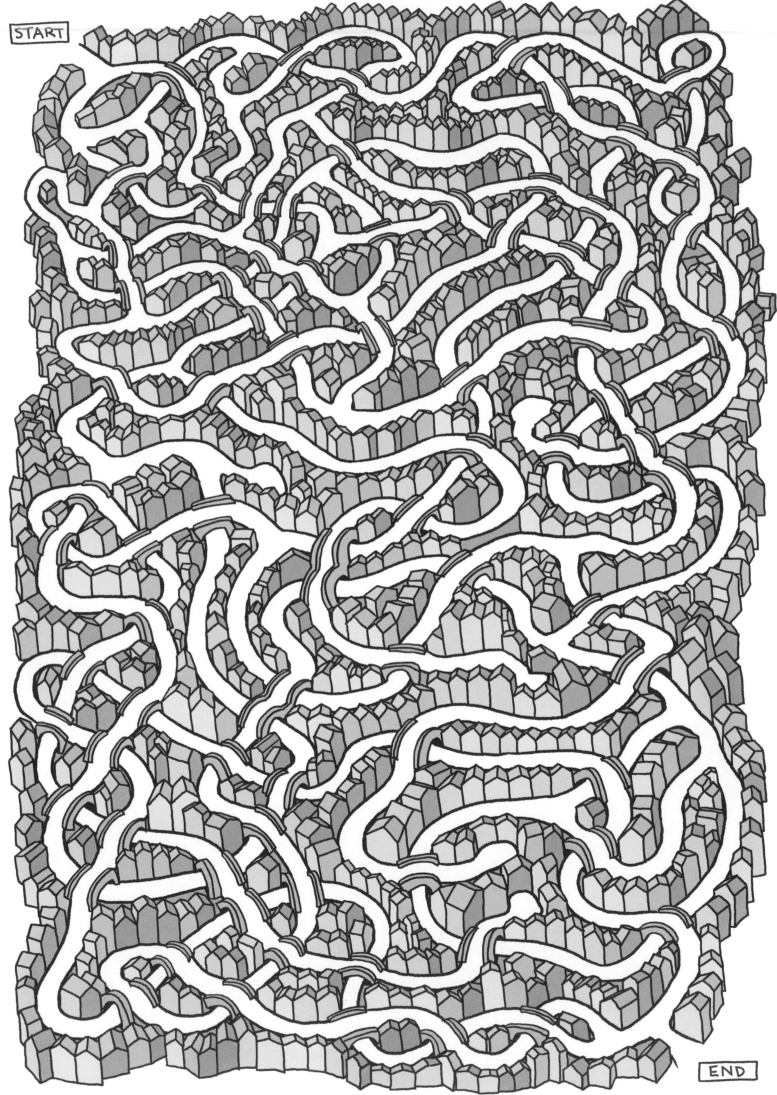

END

14 Klee Day

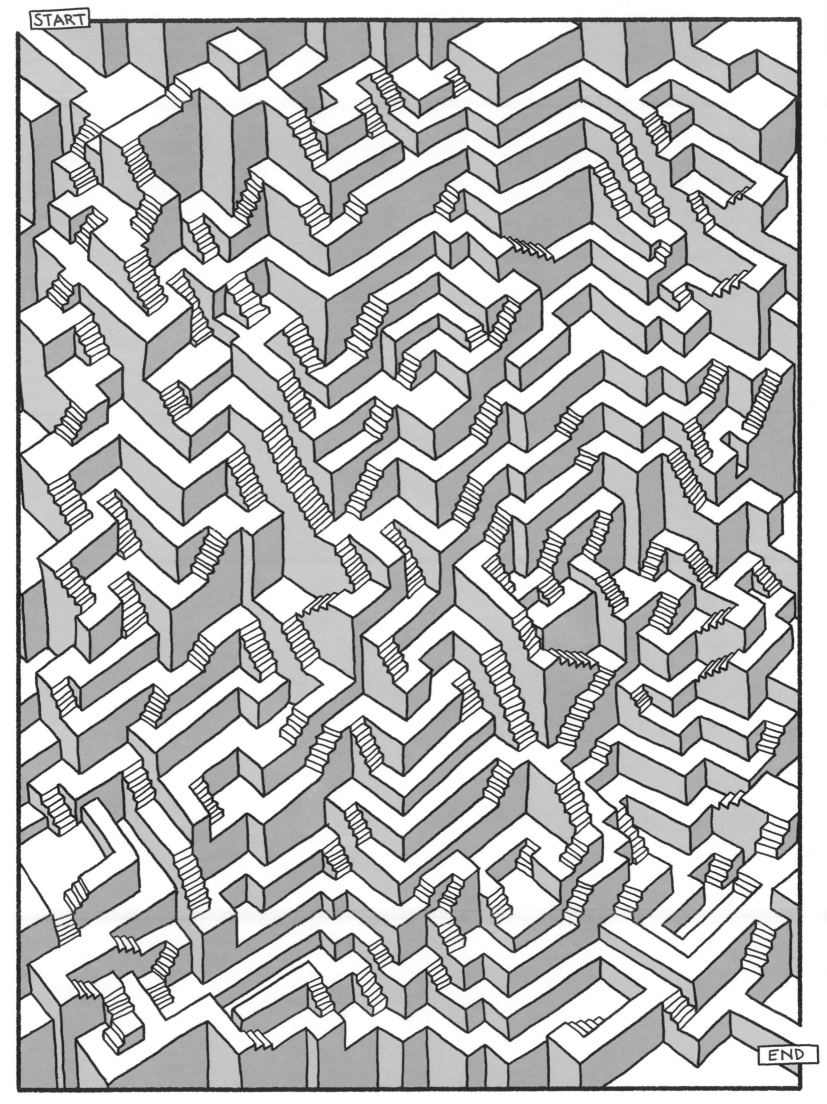

START

END

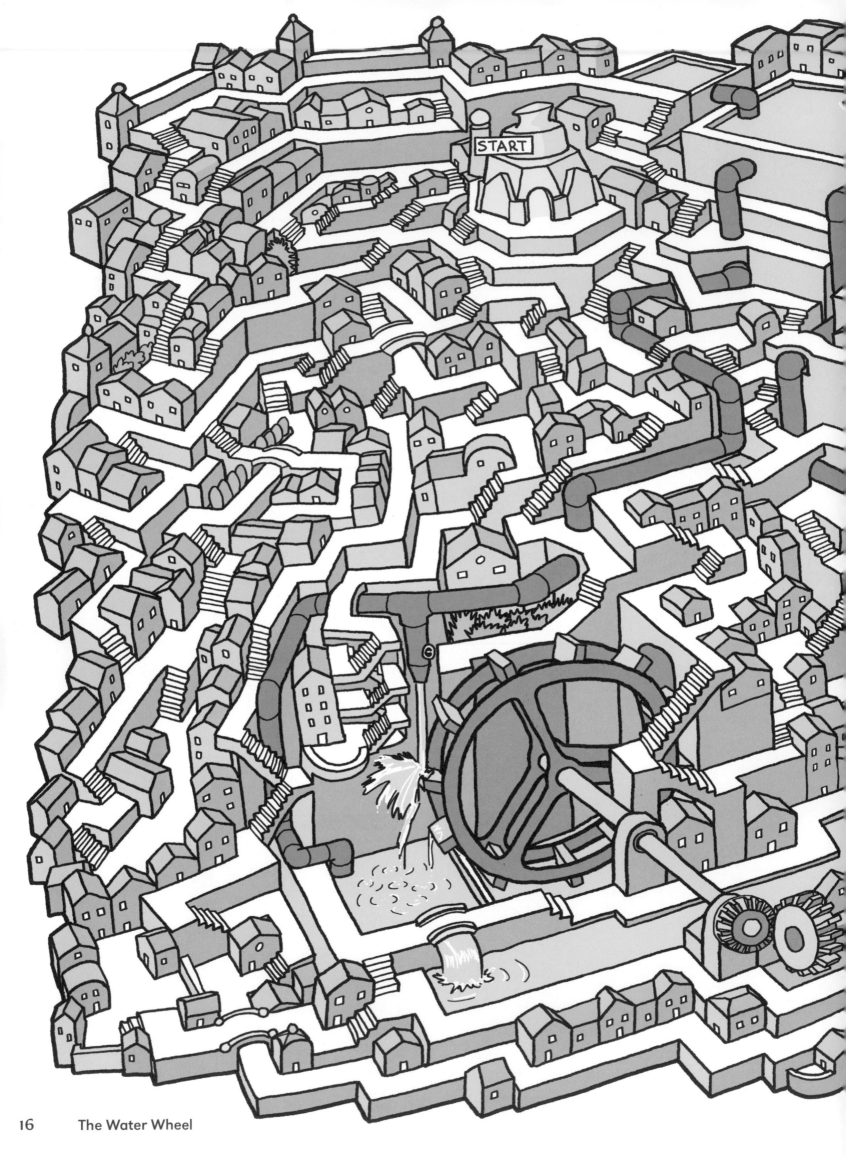

START

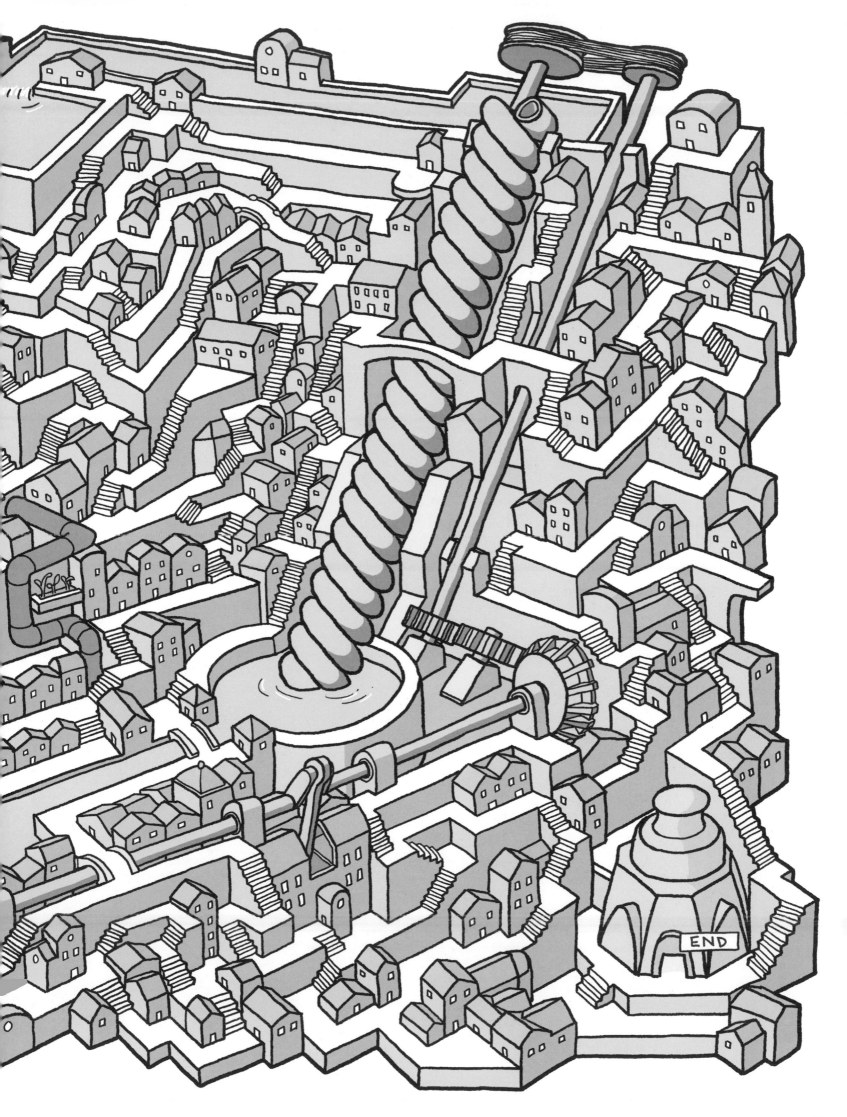

END

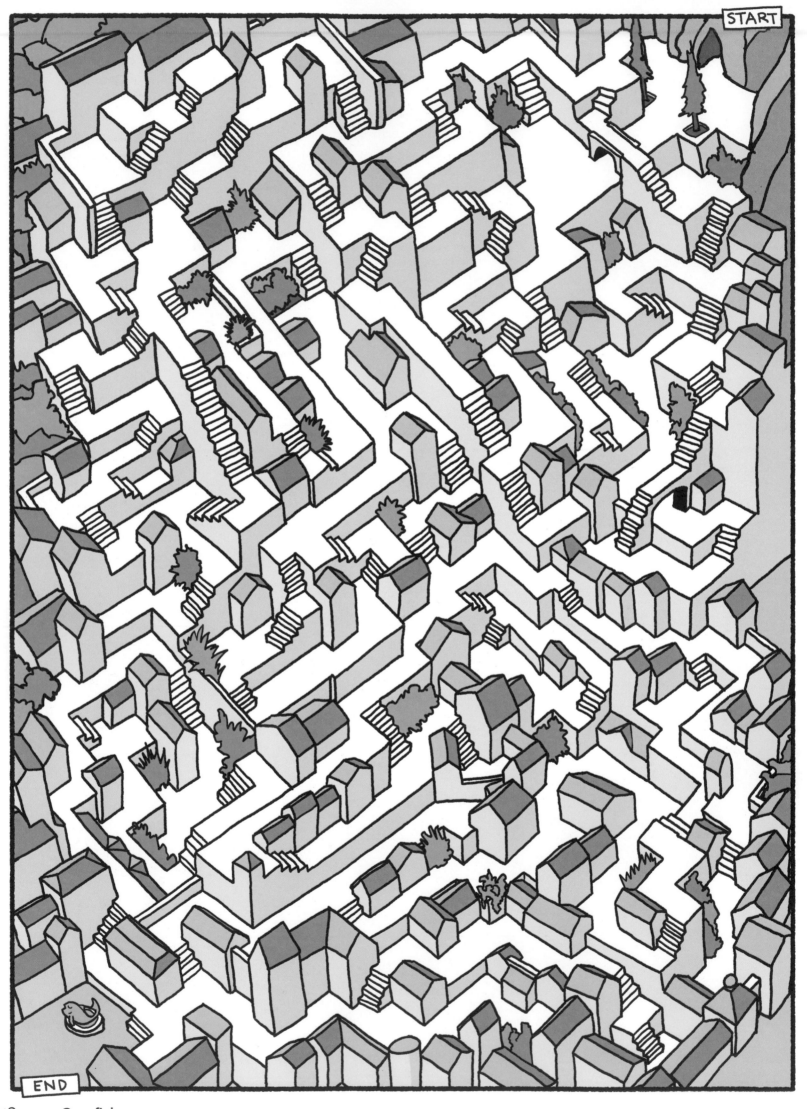

START

END

Cavefish

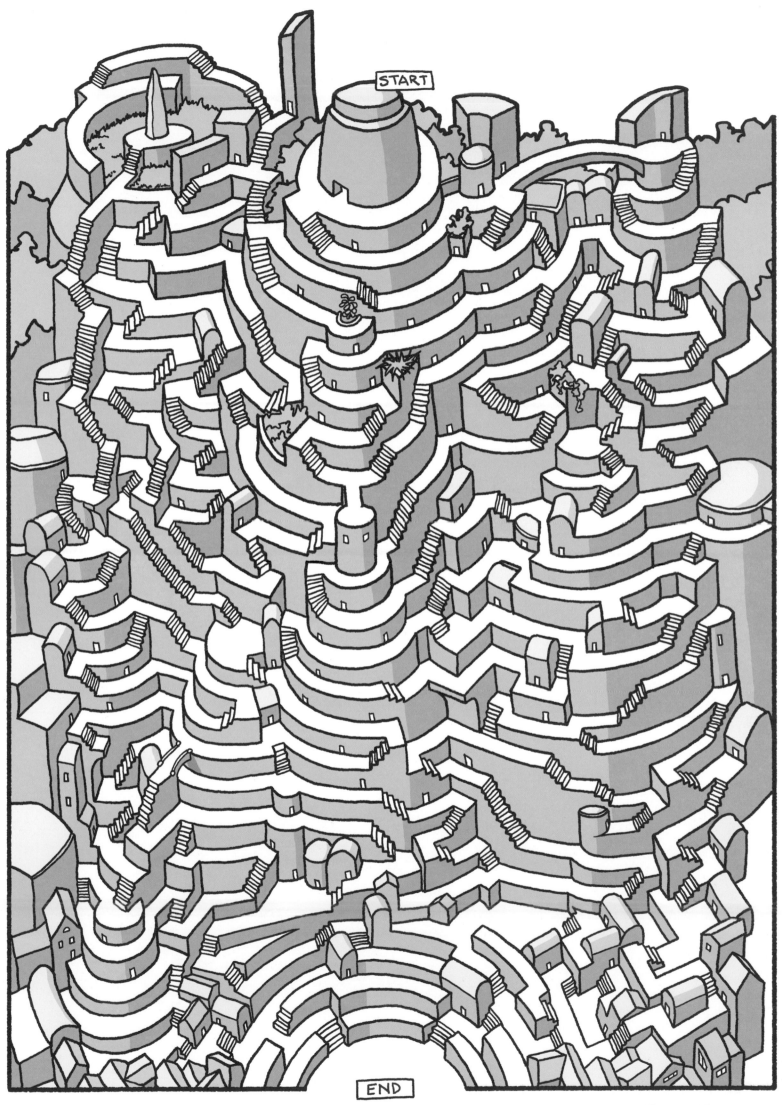

START

END

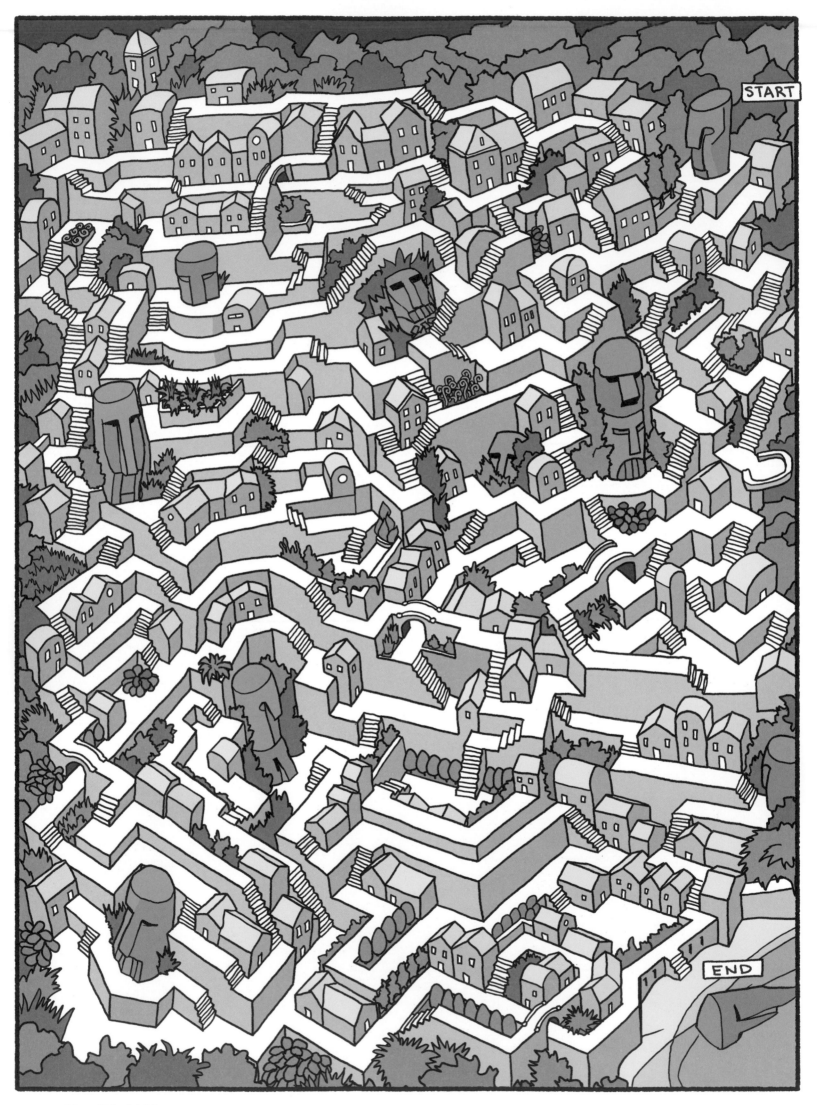

START

END

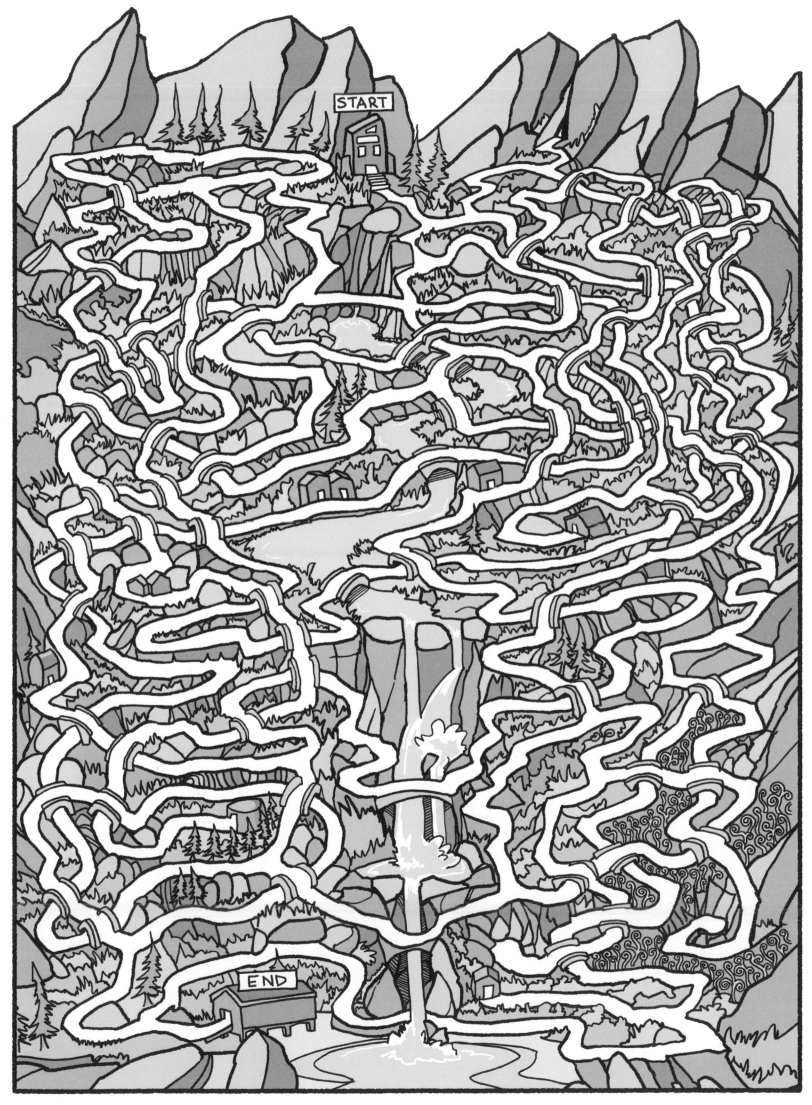

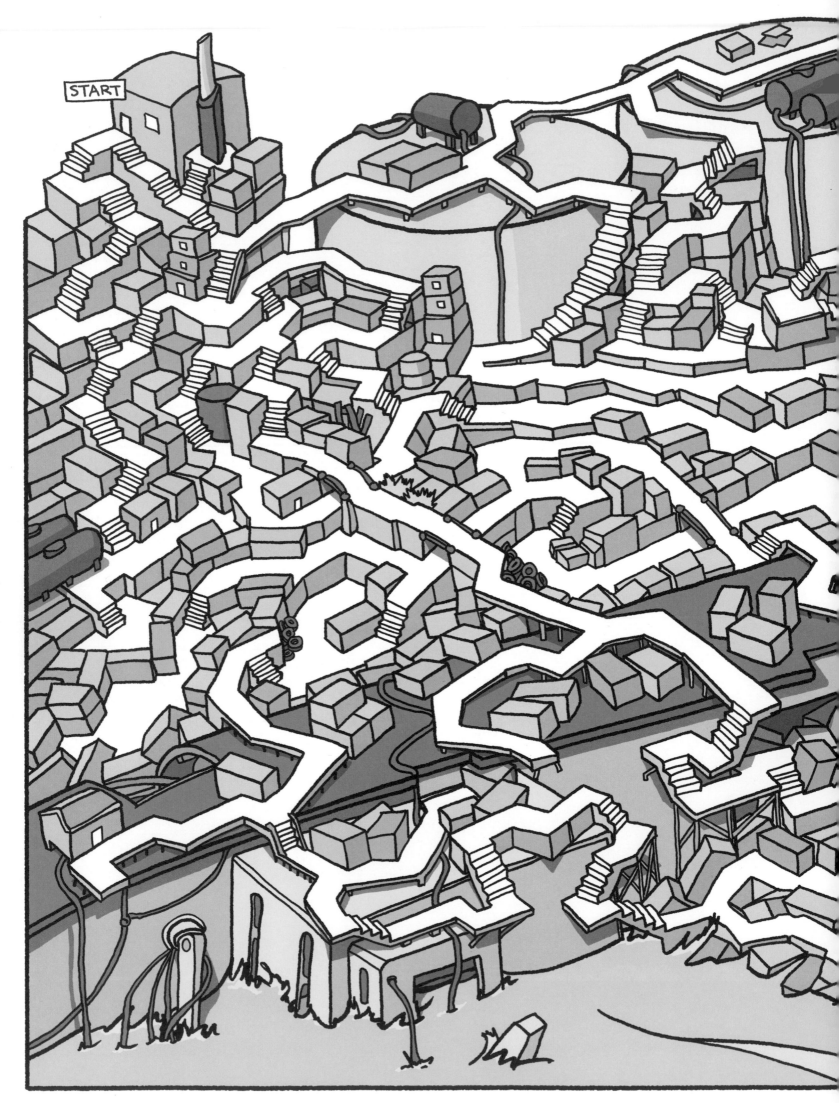

START

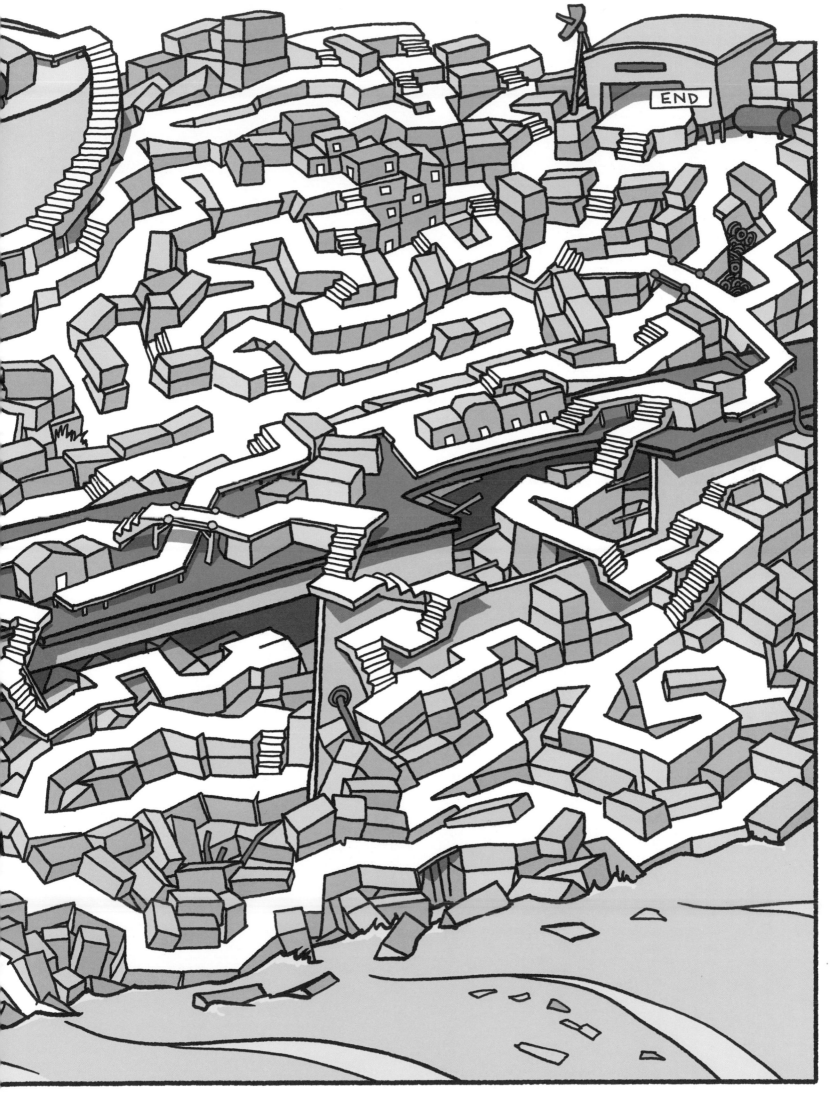

END

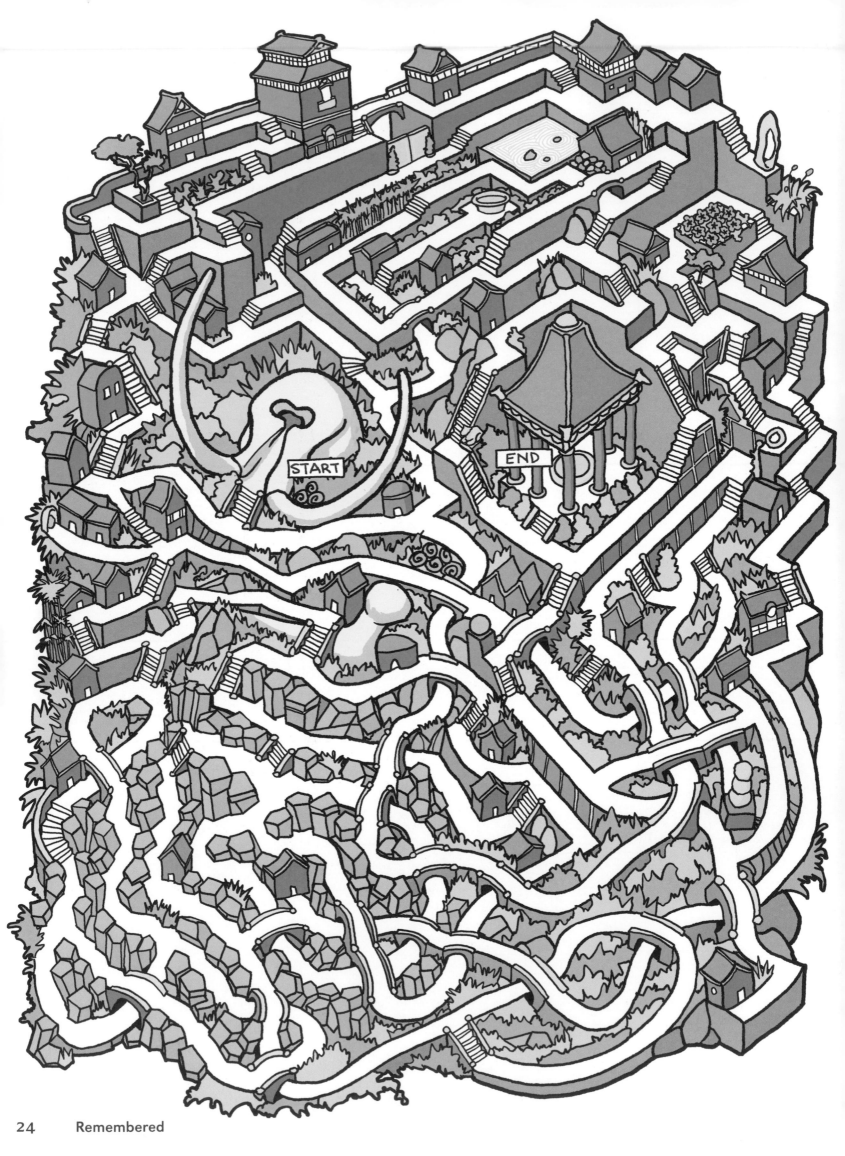

START

END

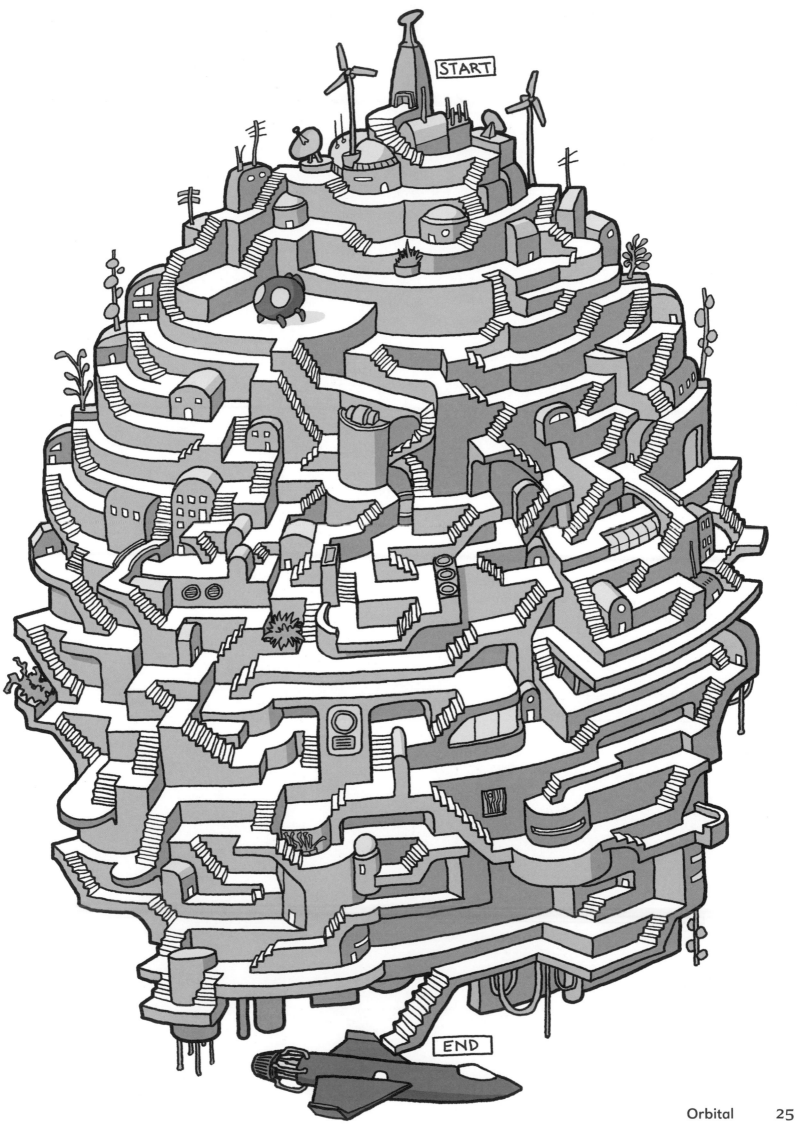

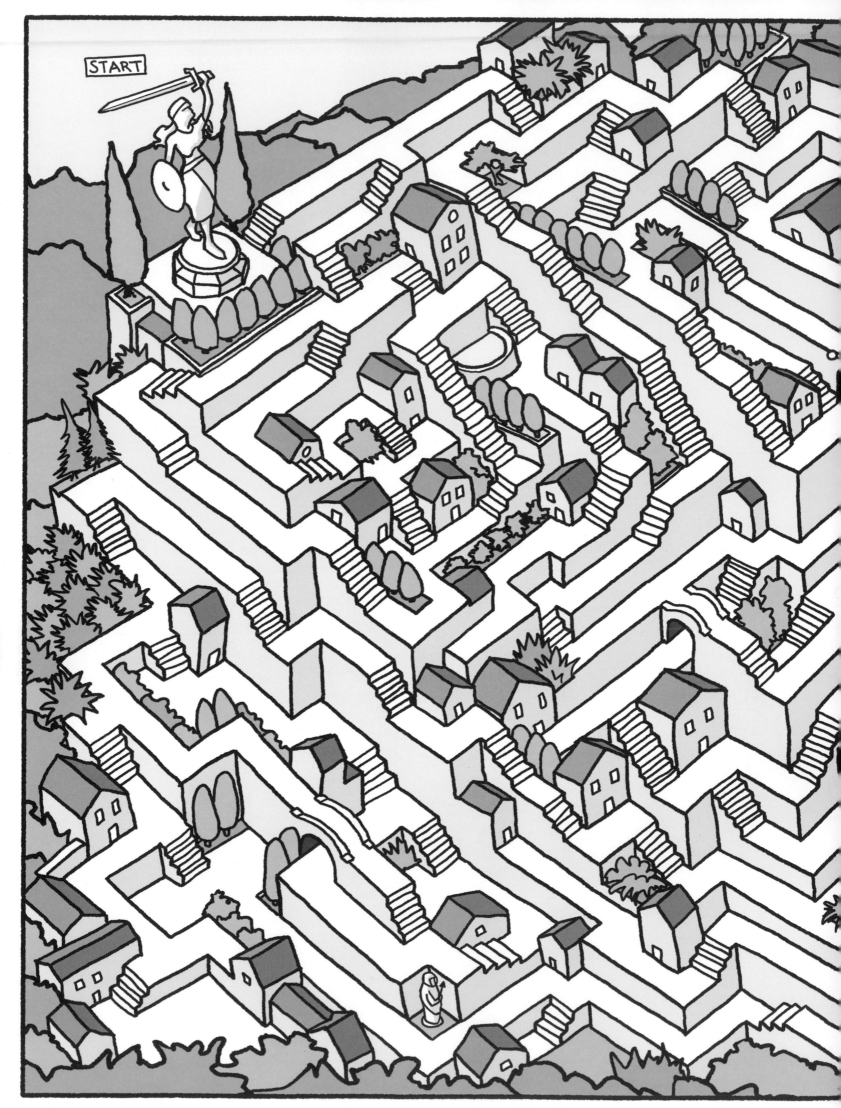

START

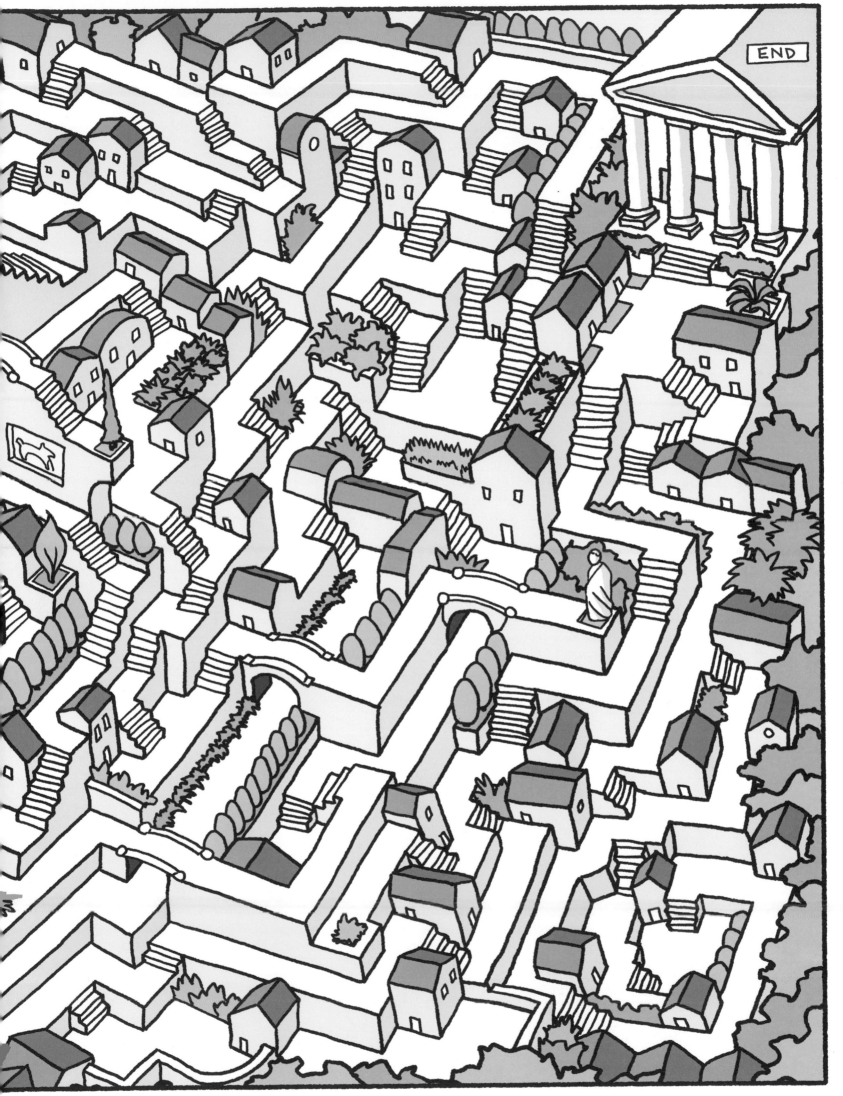

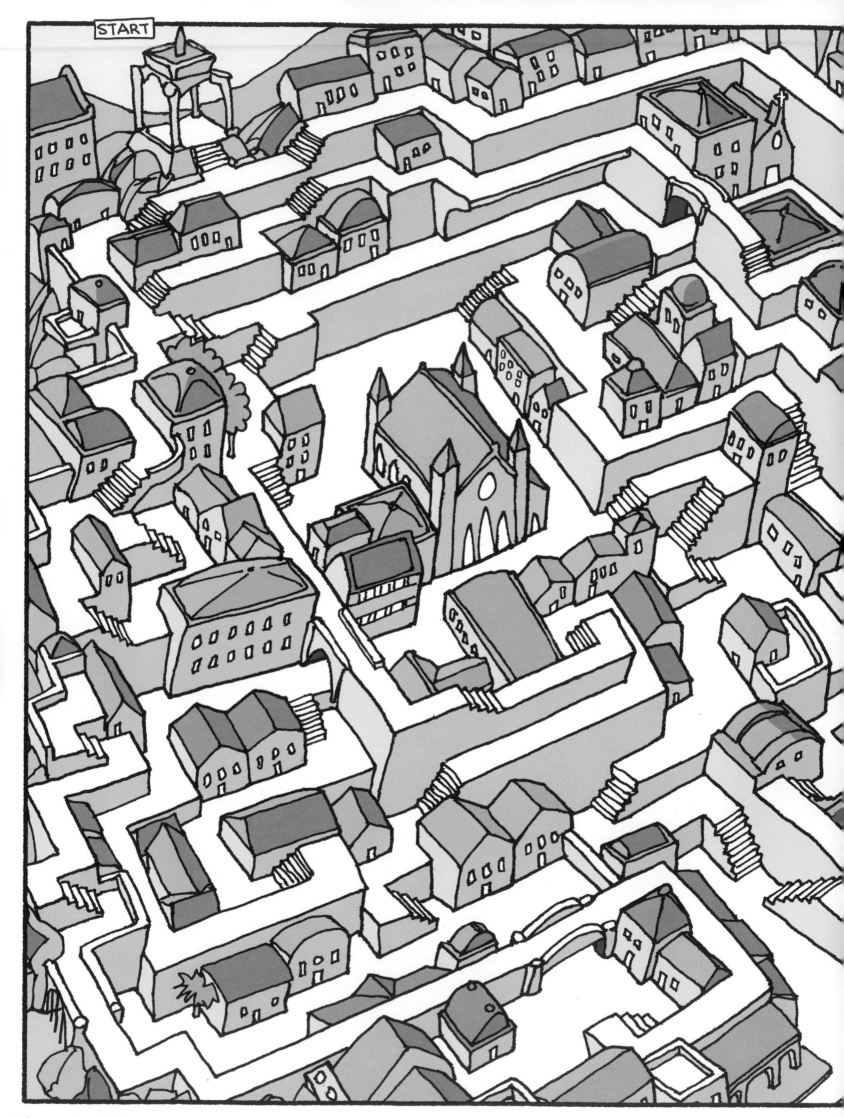

START

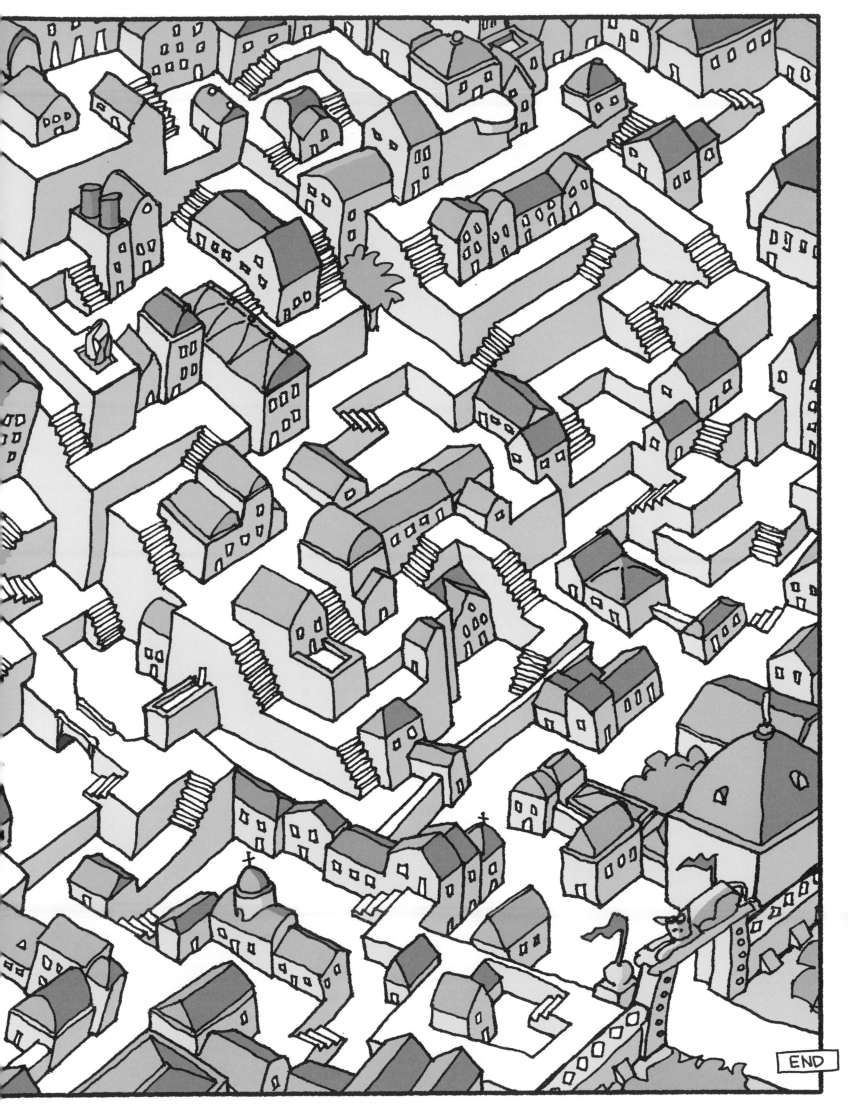

END

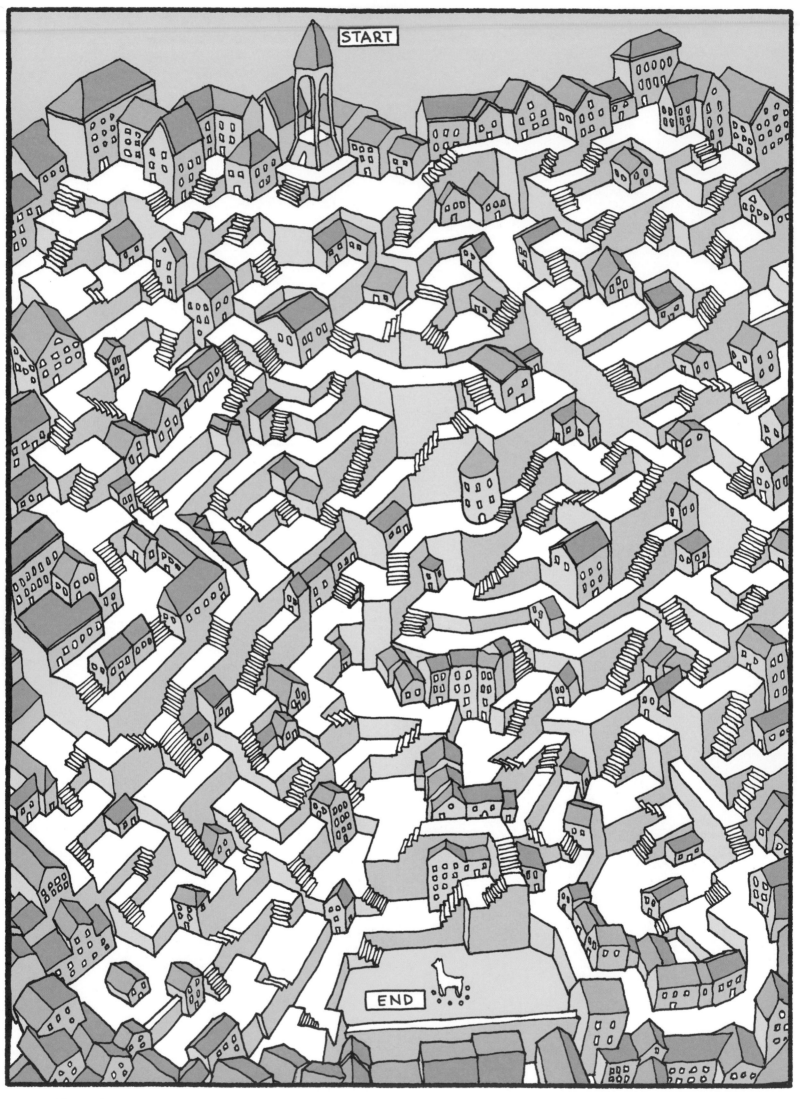

Llama Lawn

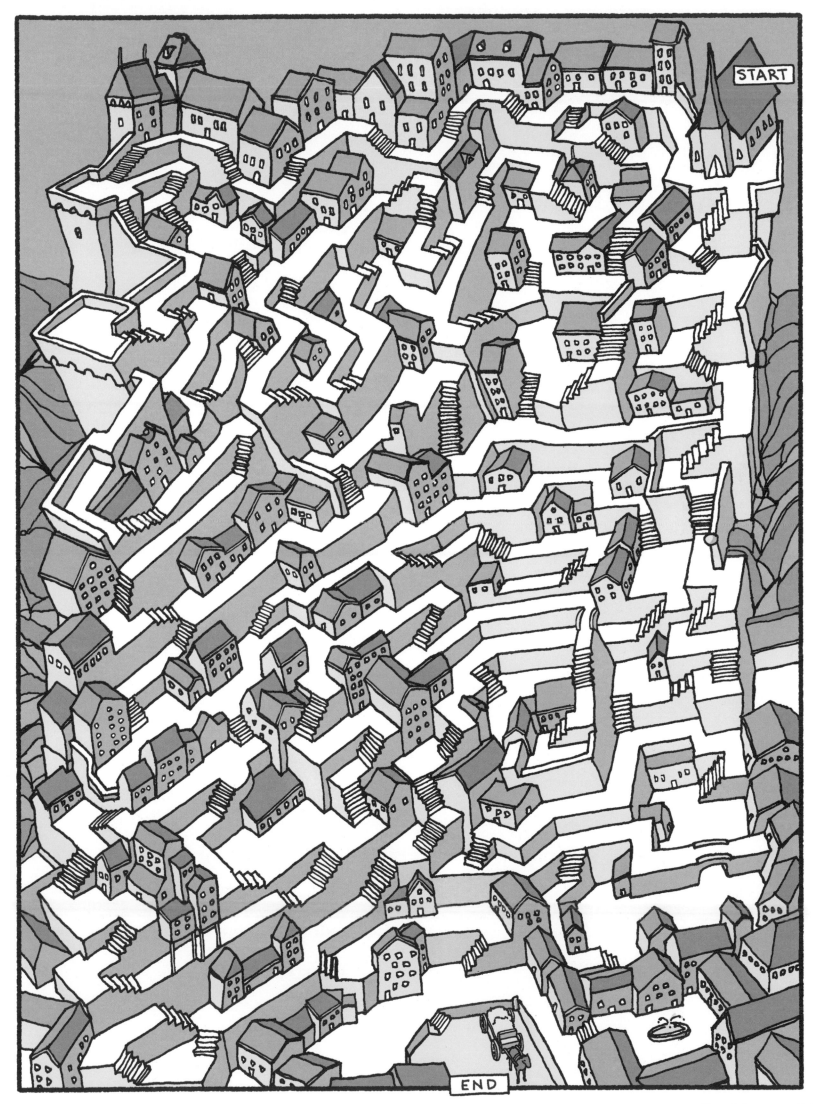

START

END

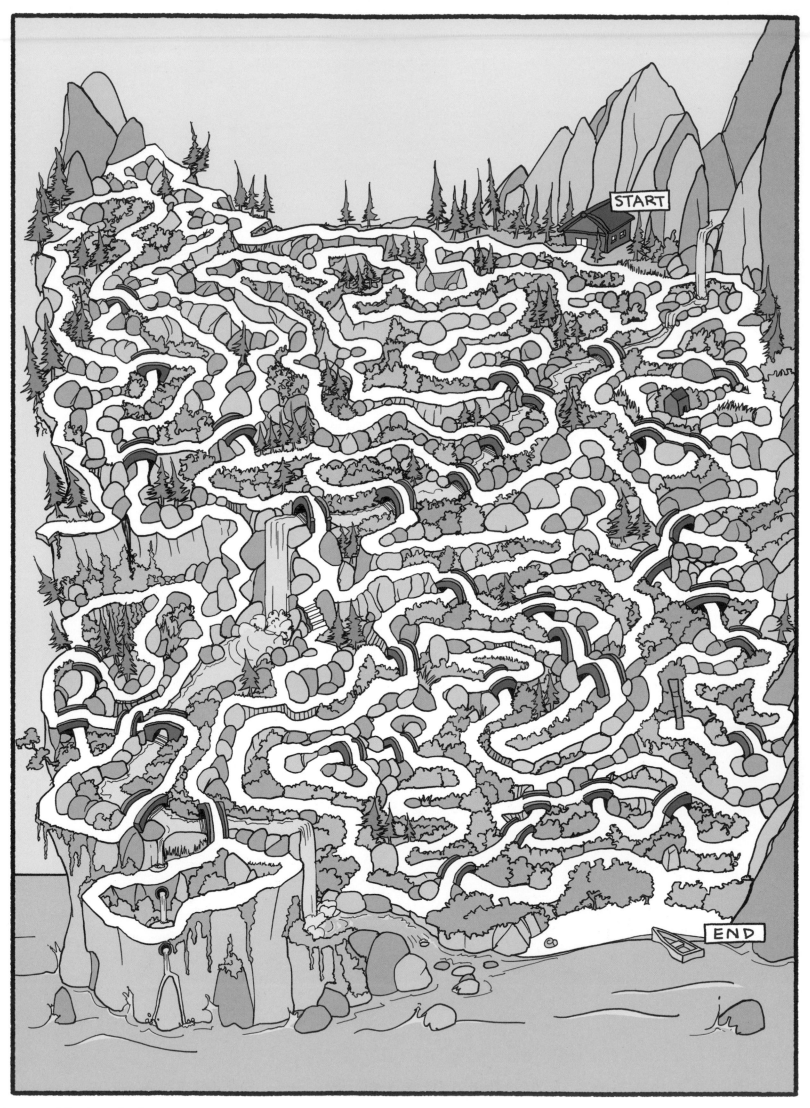

The Lost Lodge

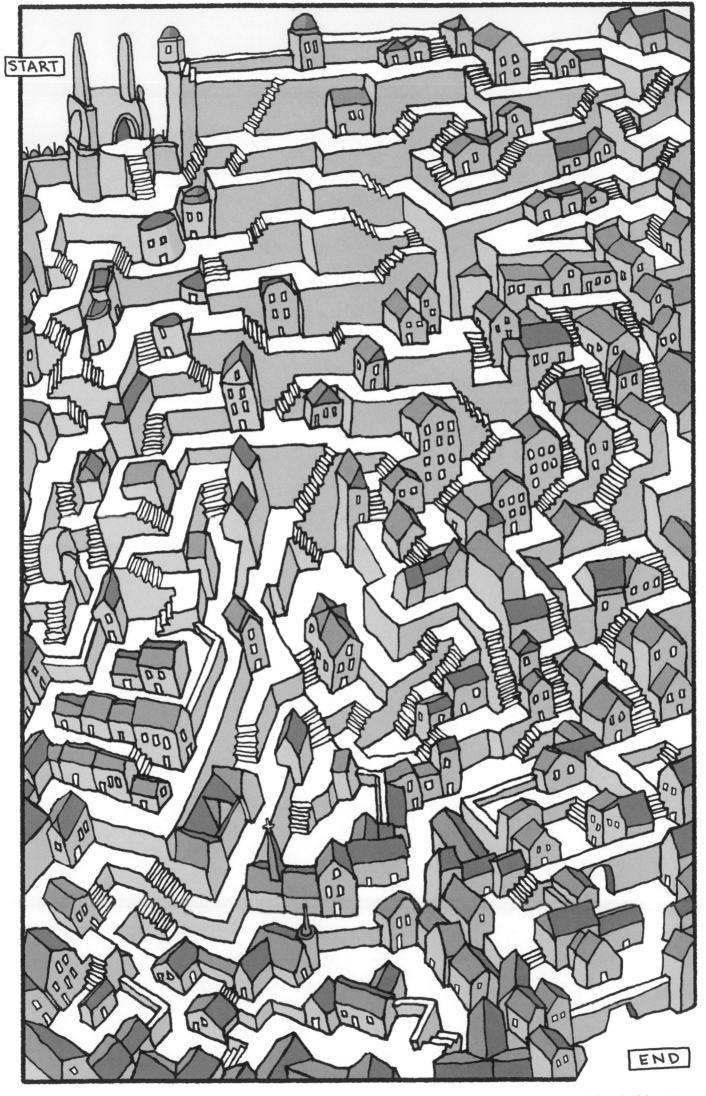

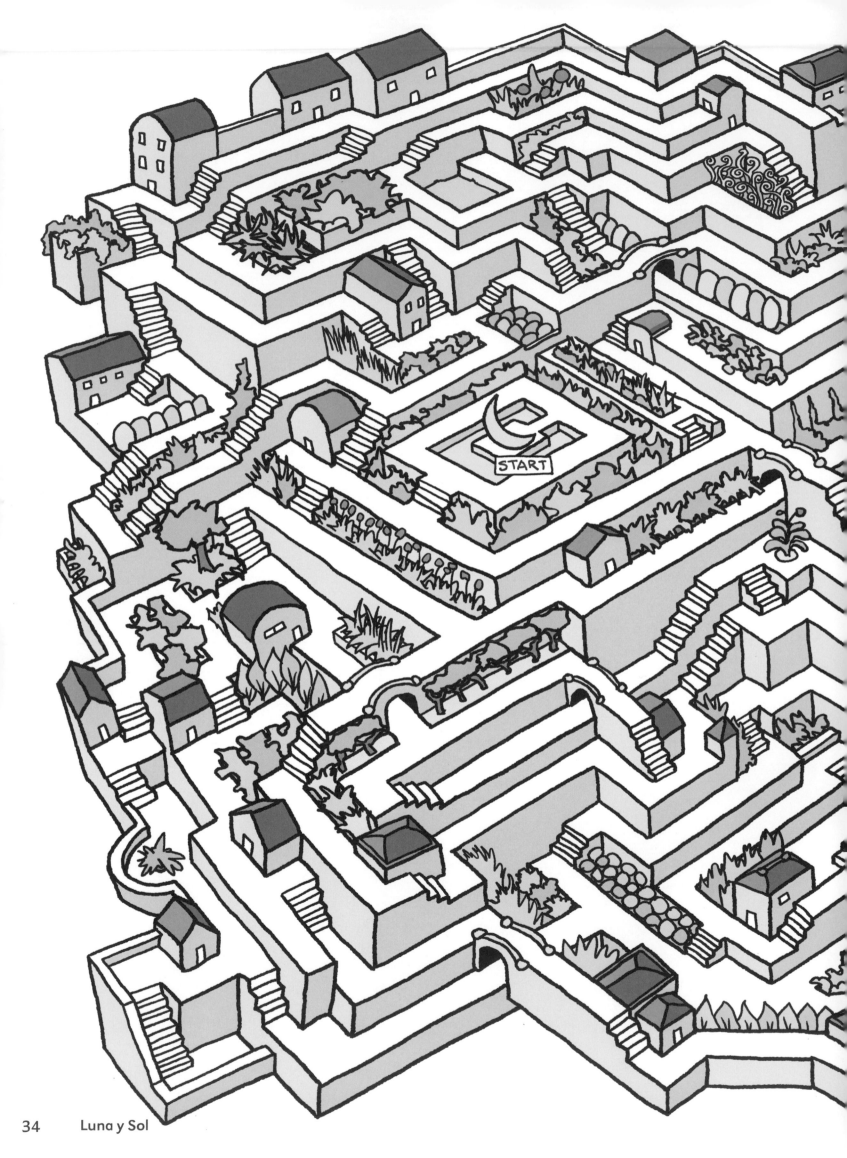

START

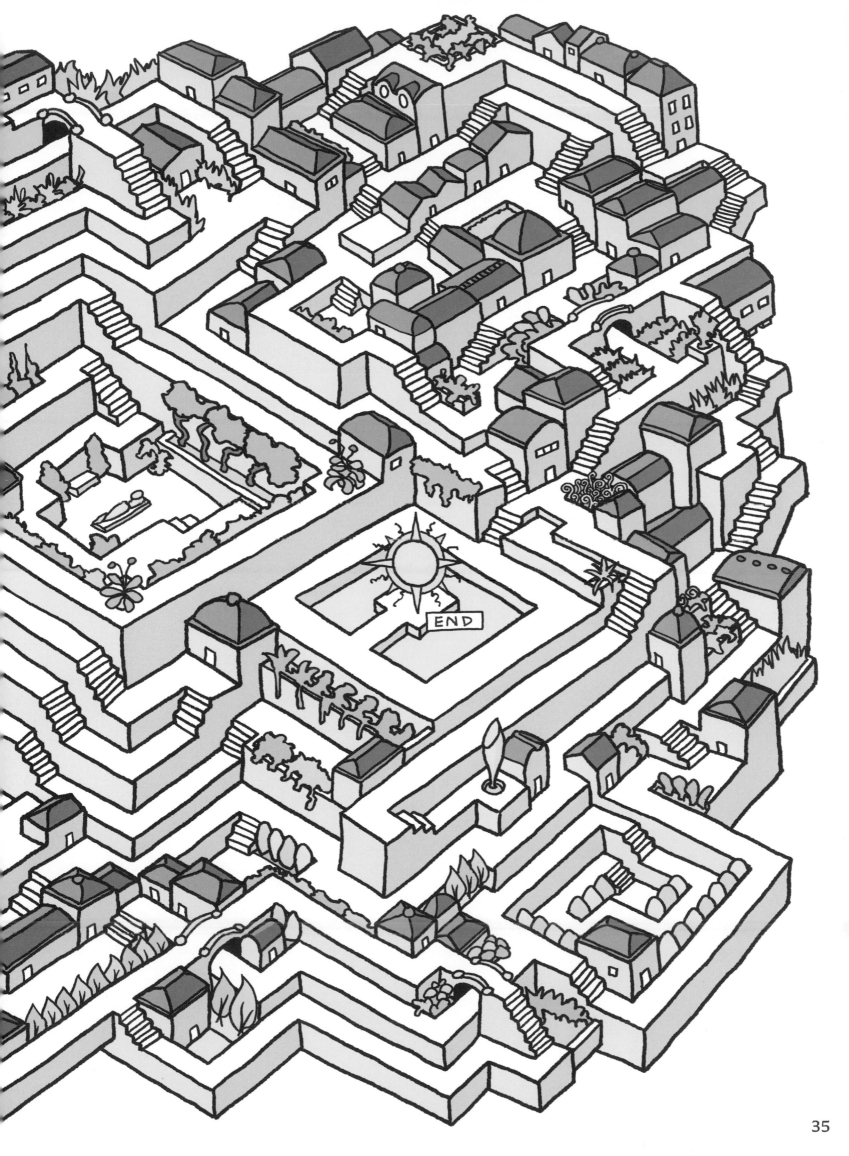

END

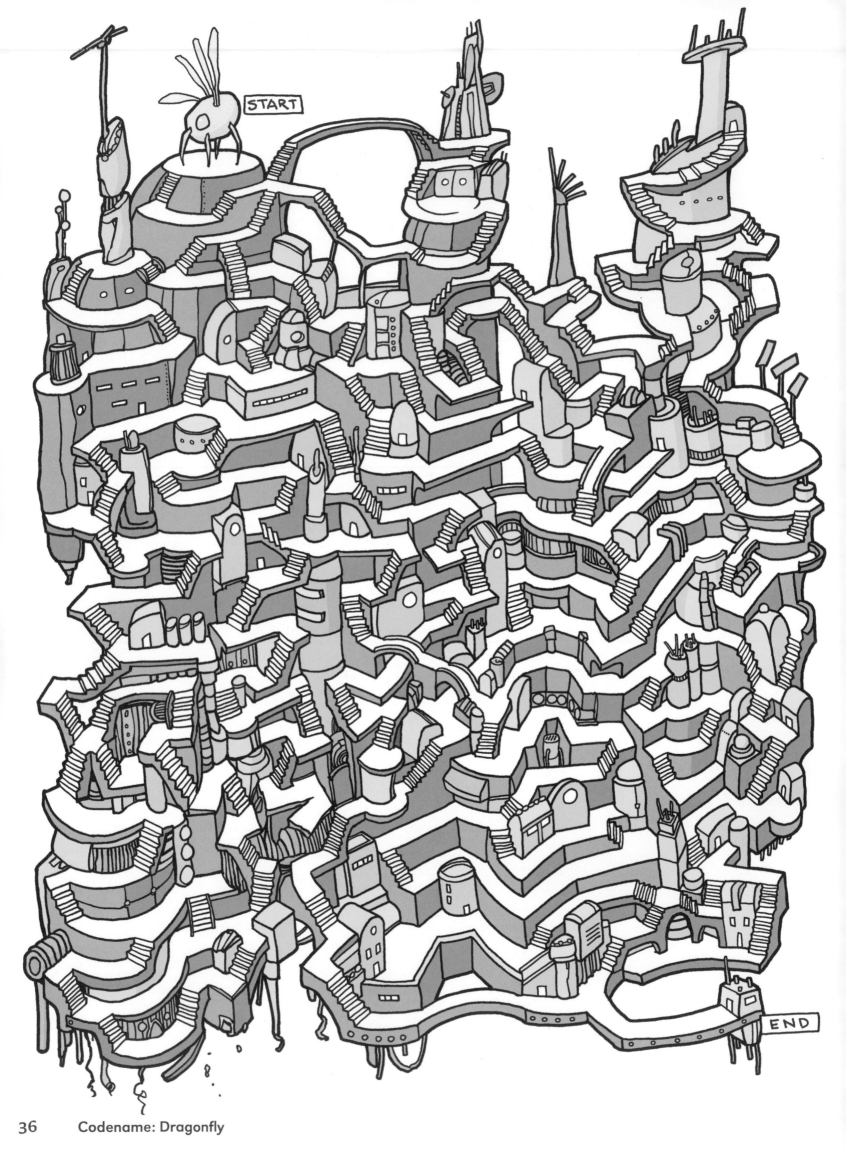

START

END

Codename: Dragonfly

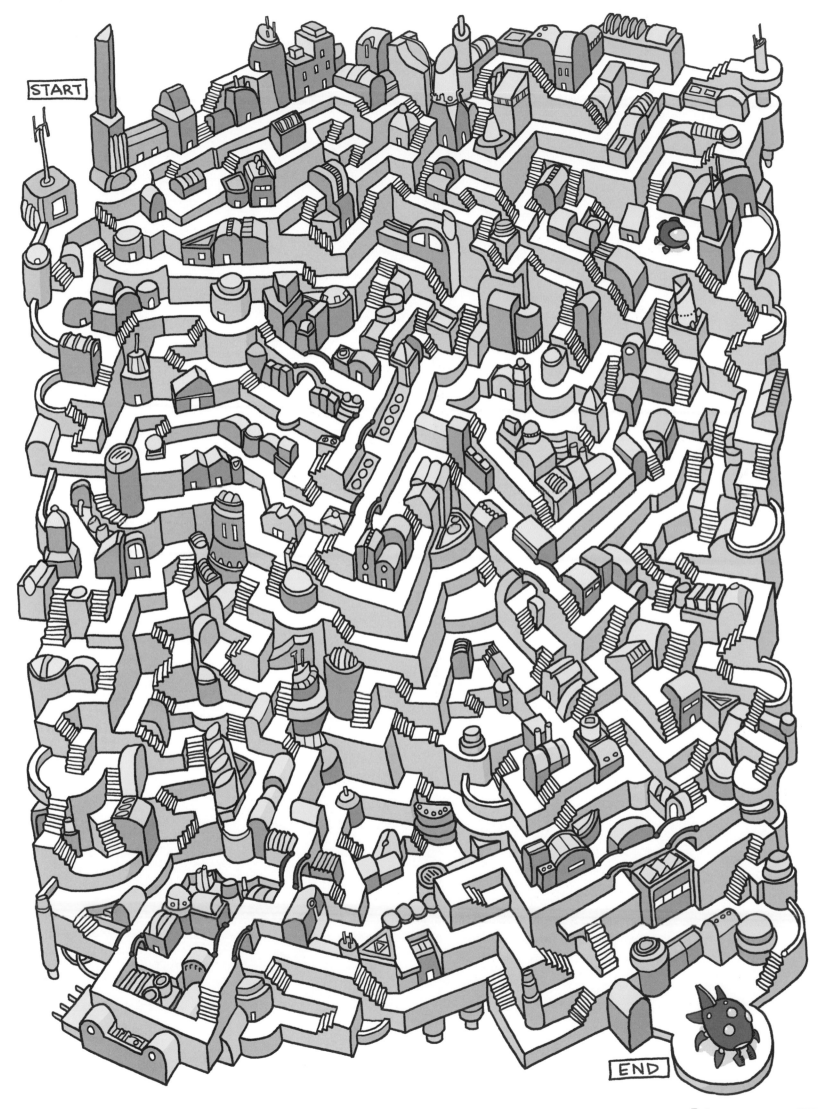

START

END

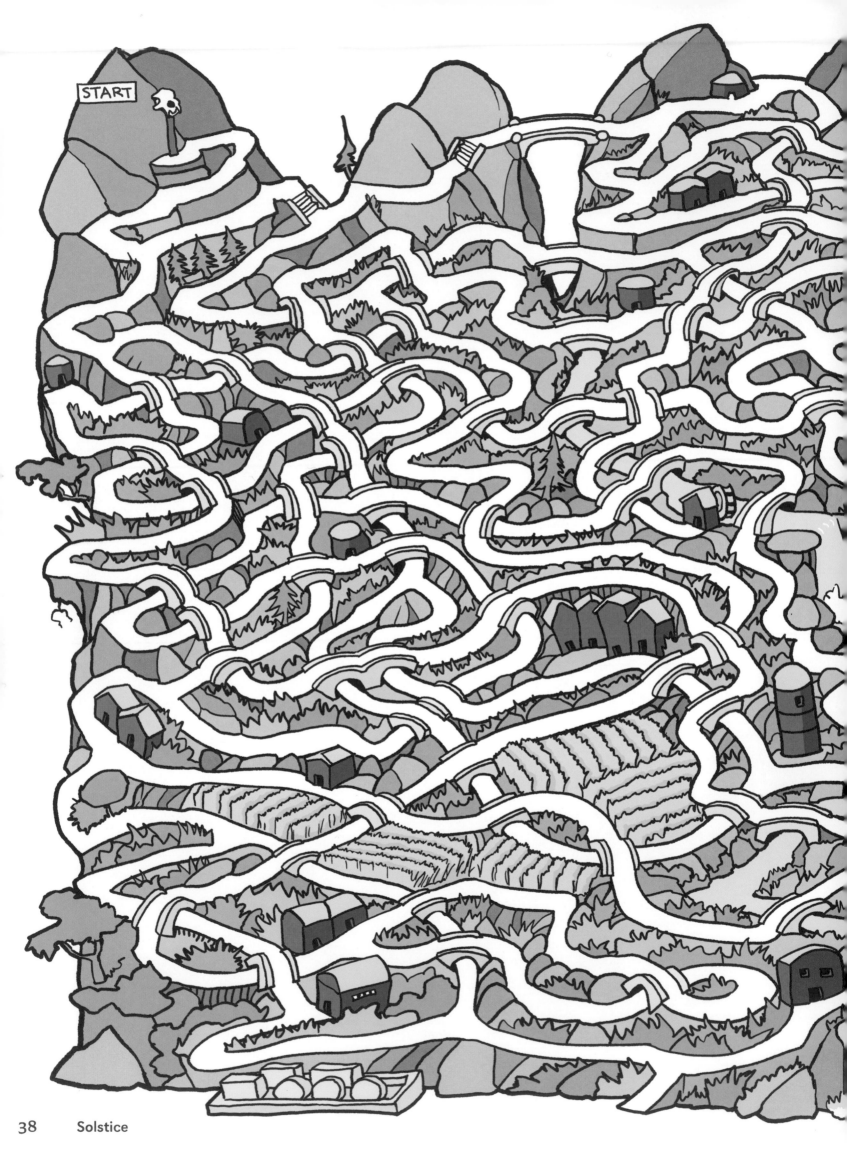

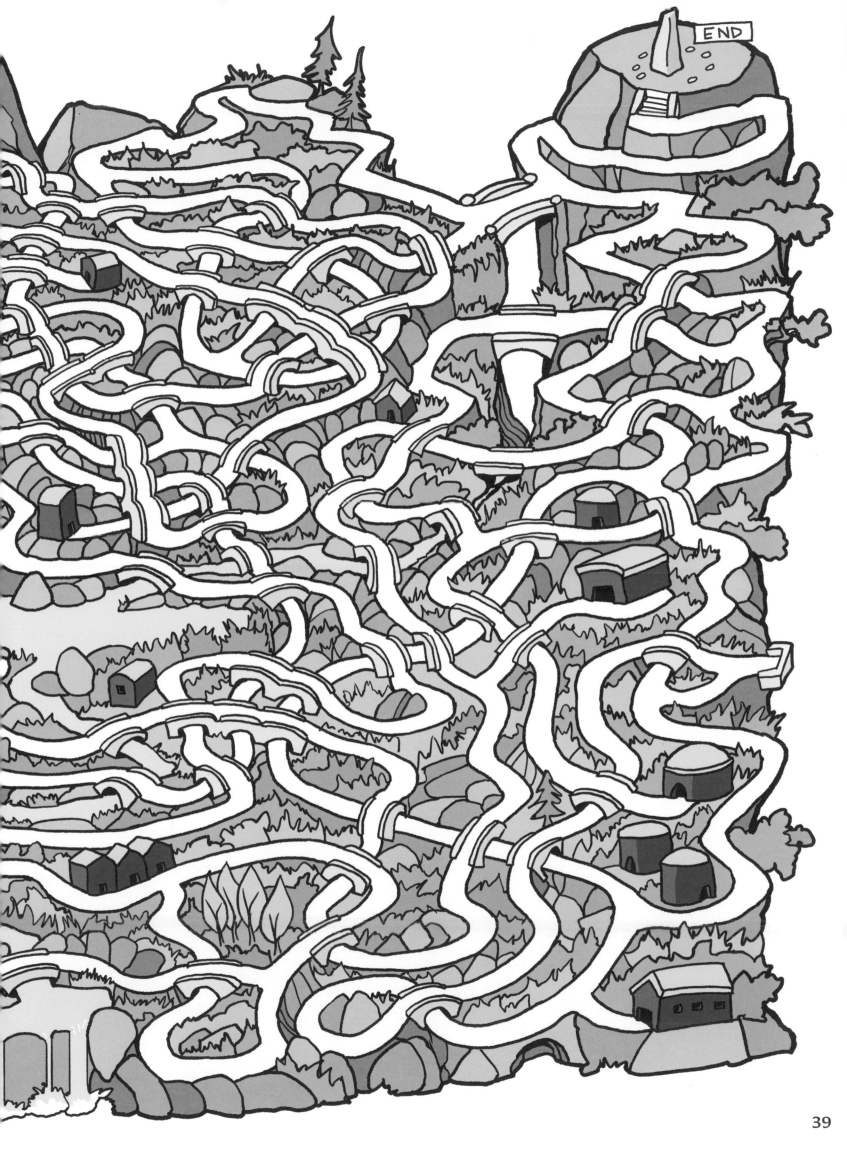

END

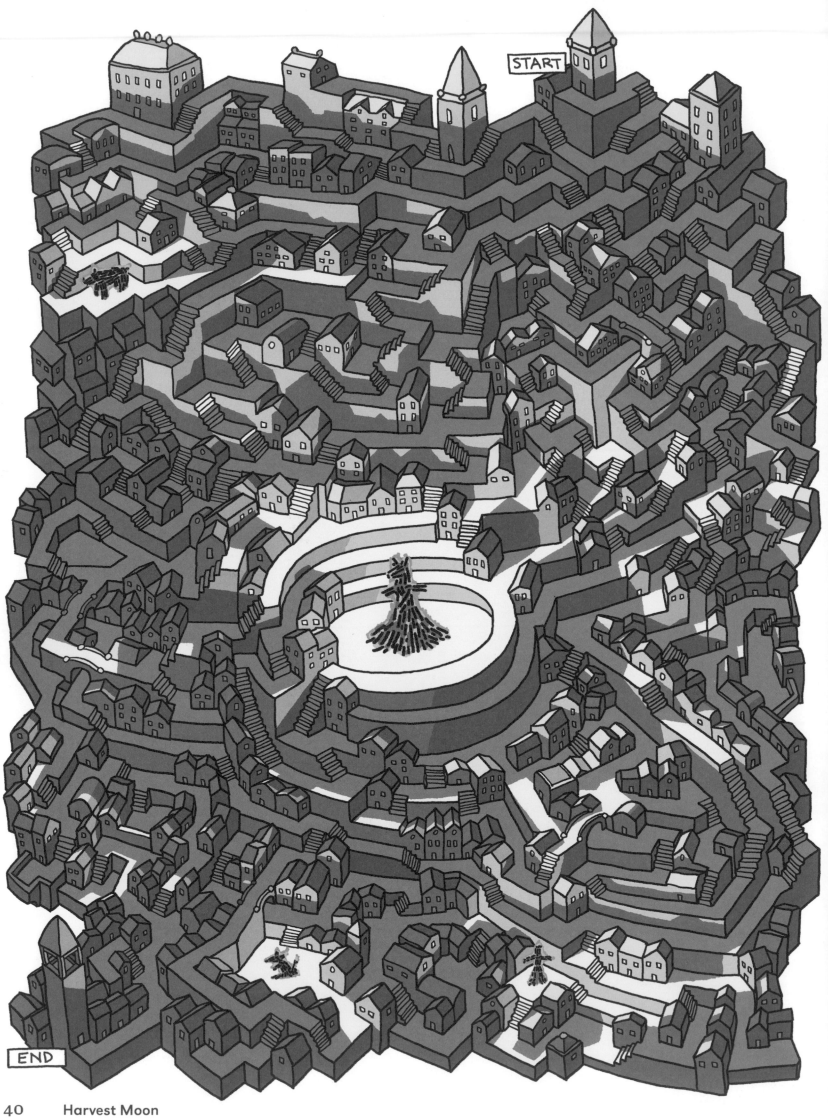

START

END

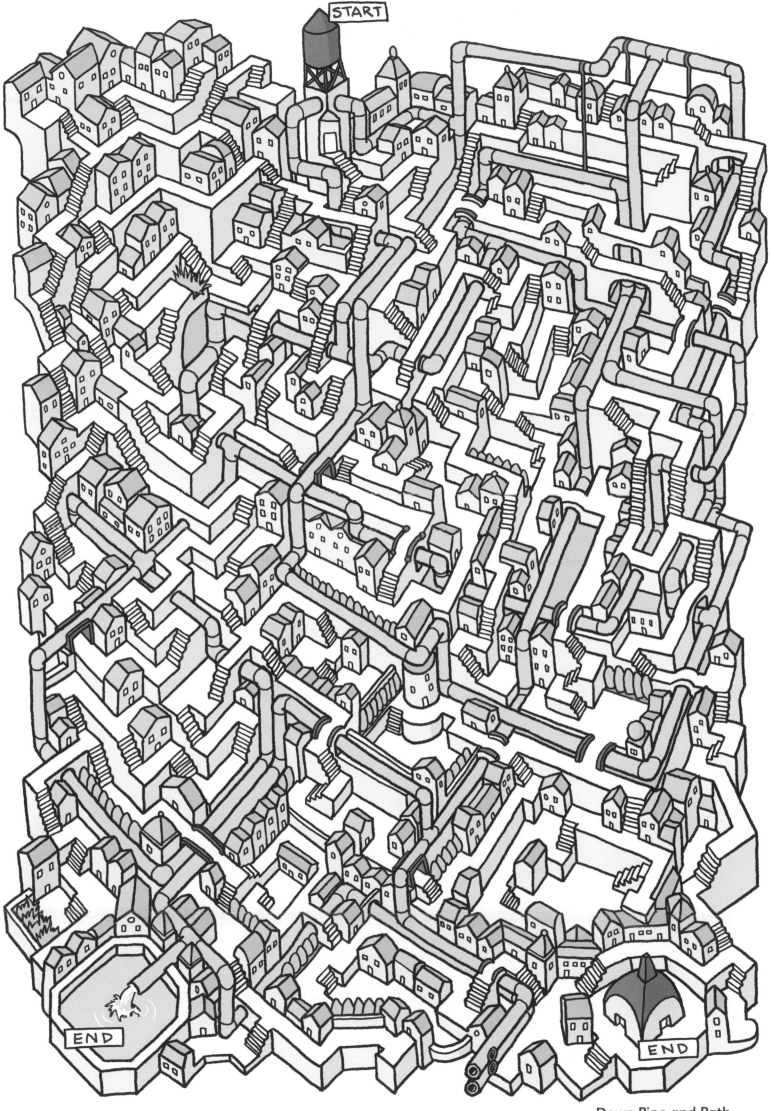

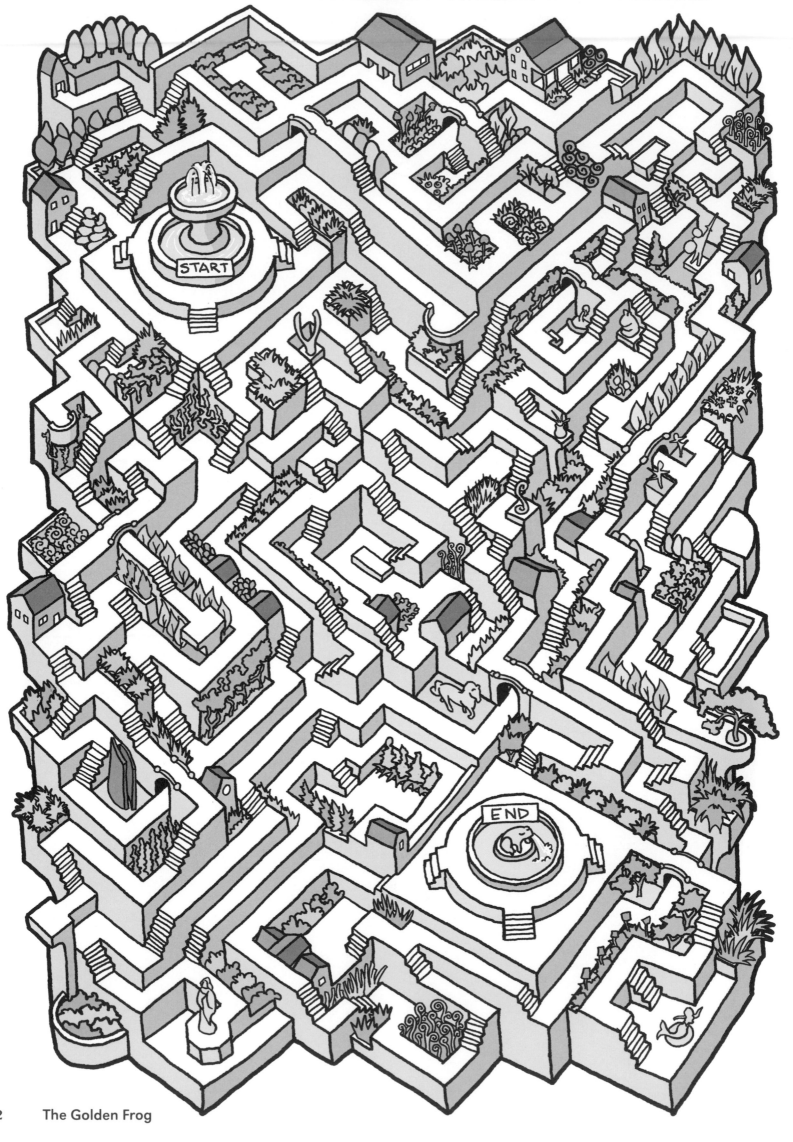

The Golden Frog

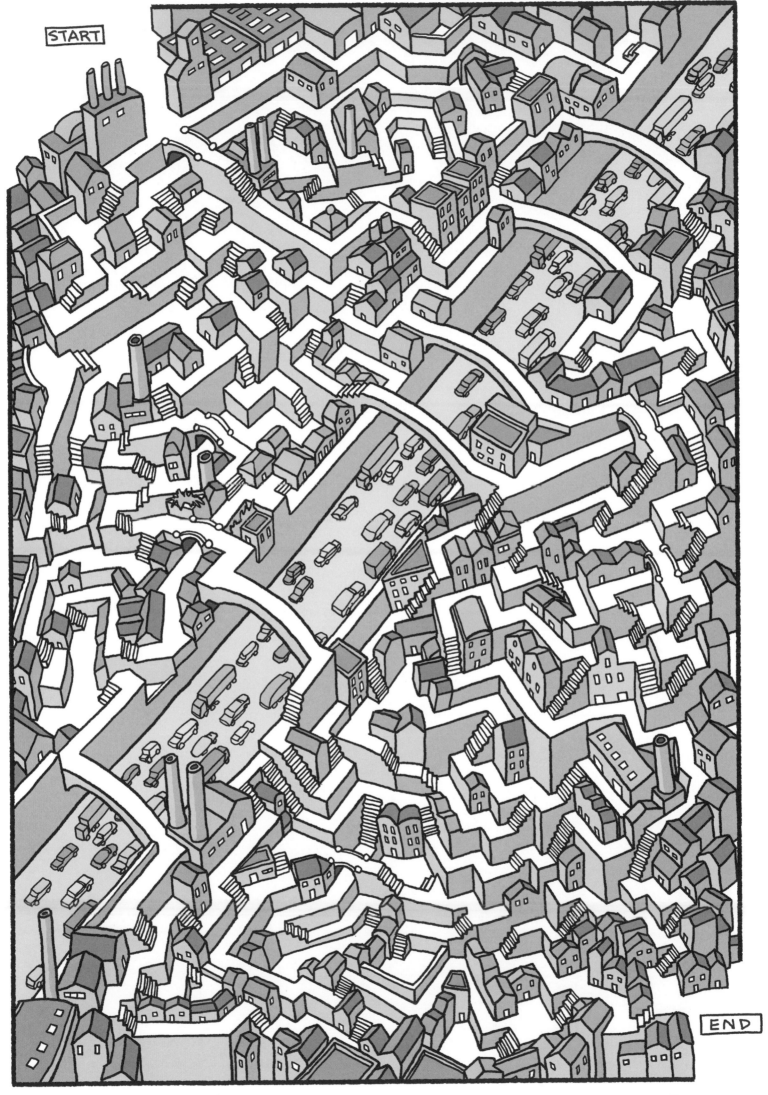

START

END

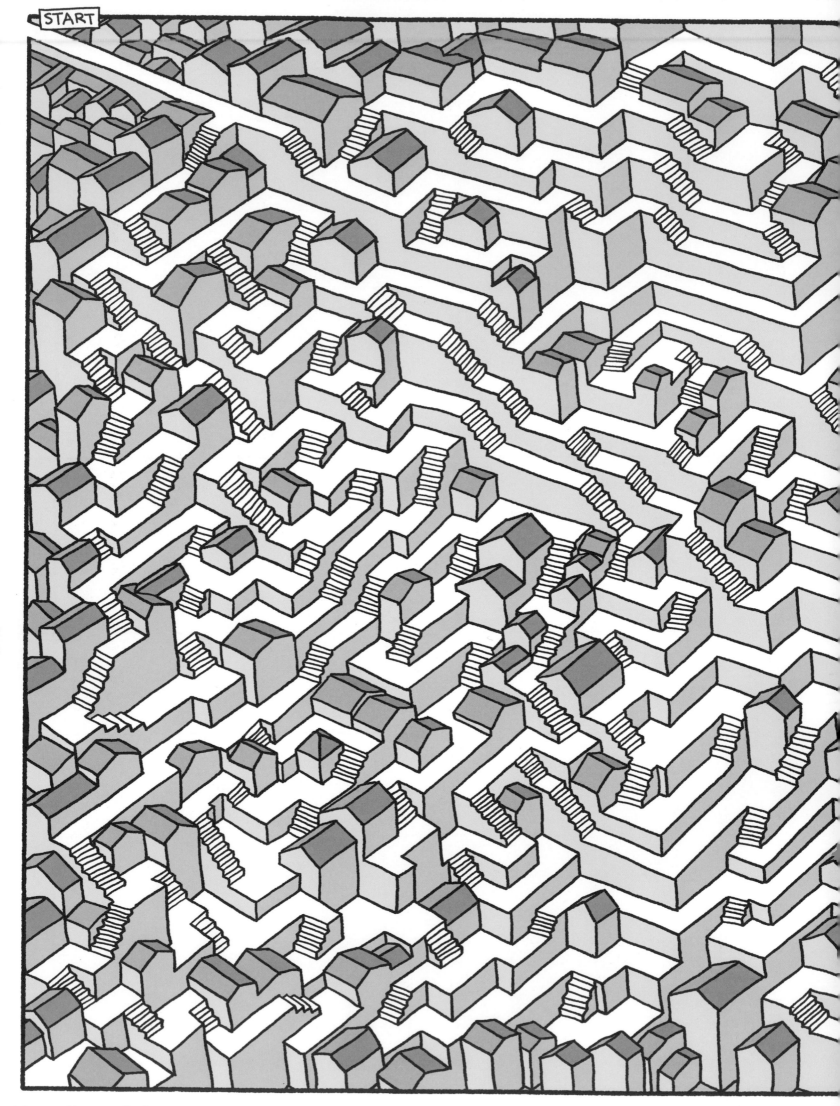

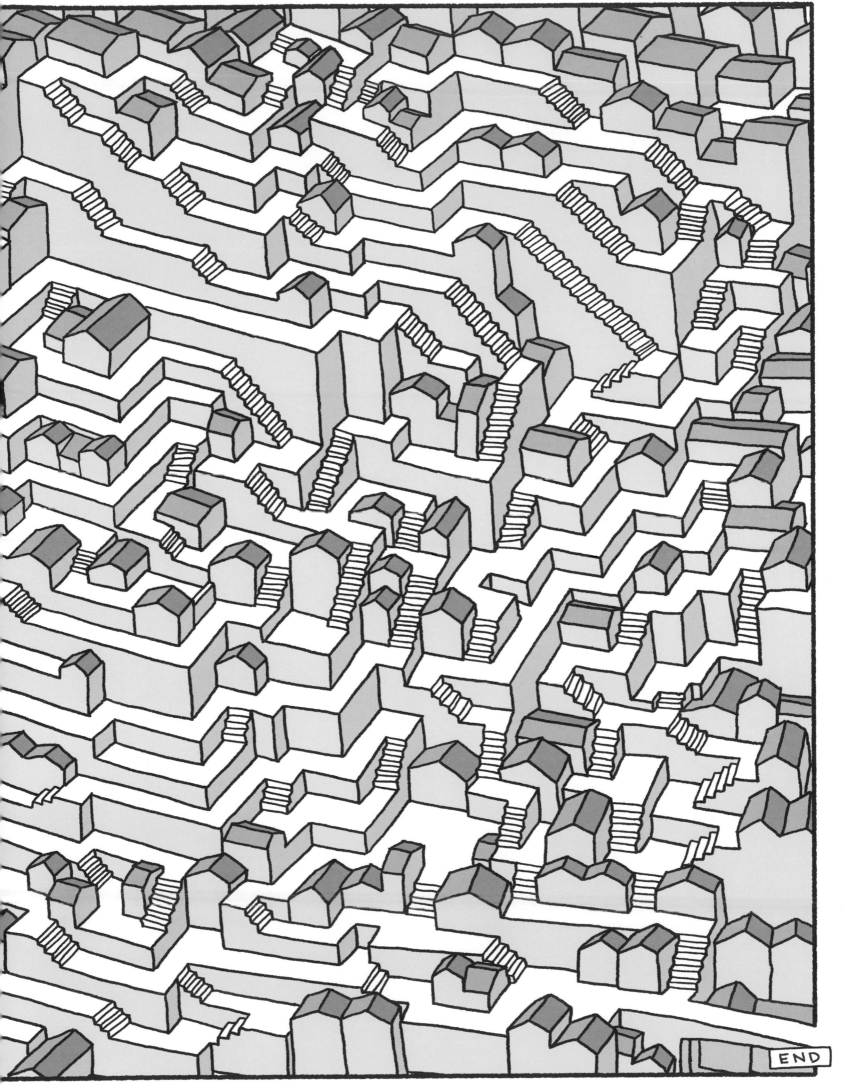

END

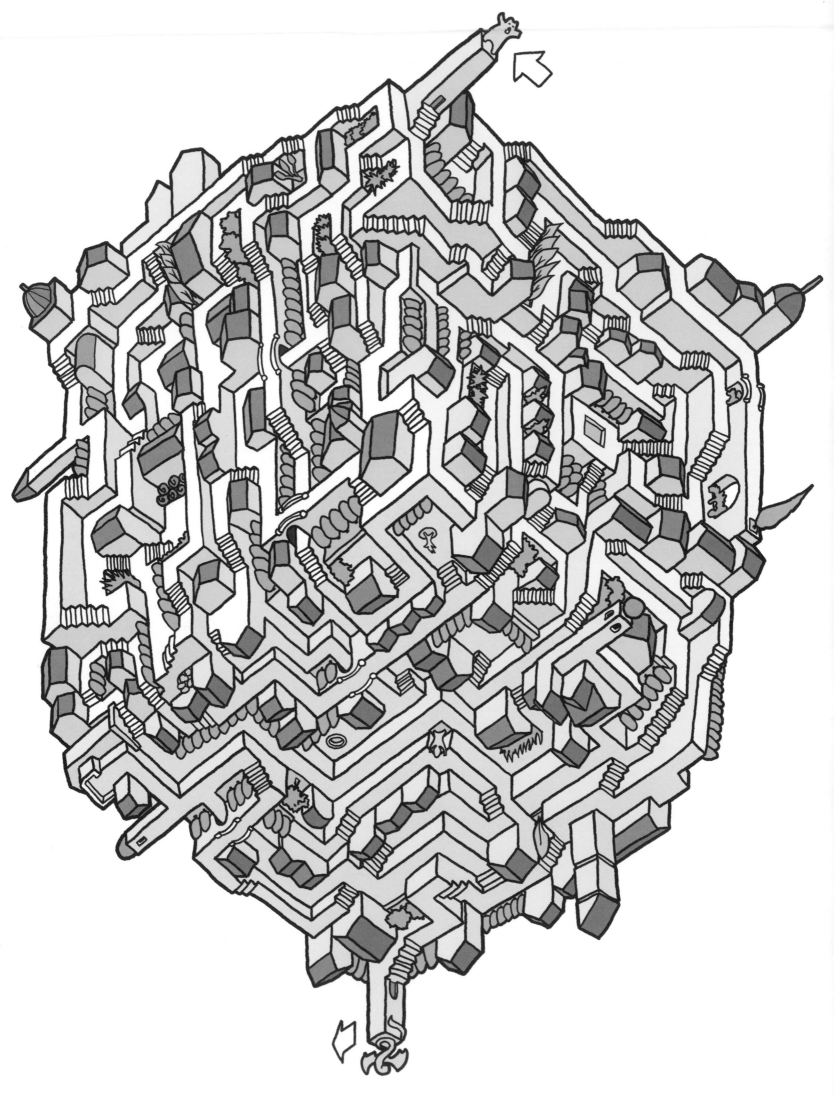

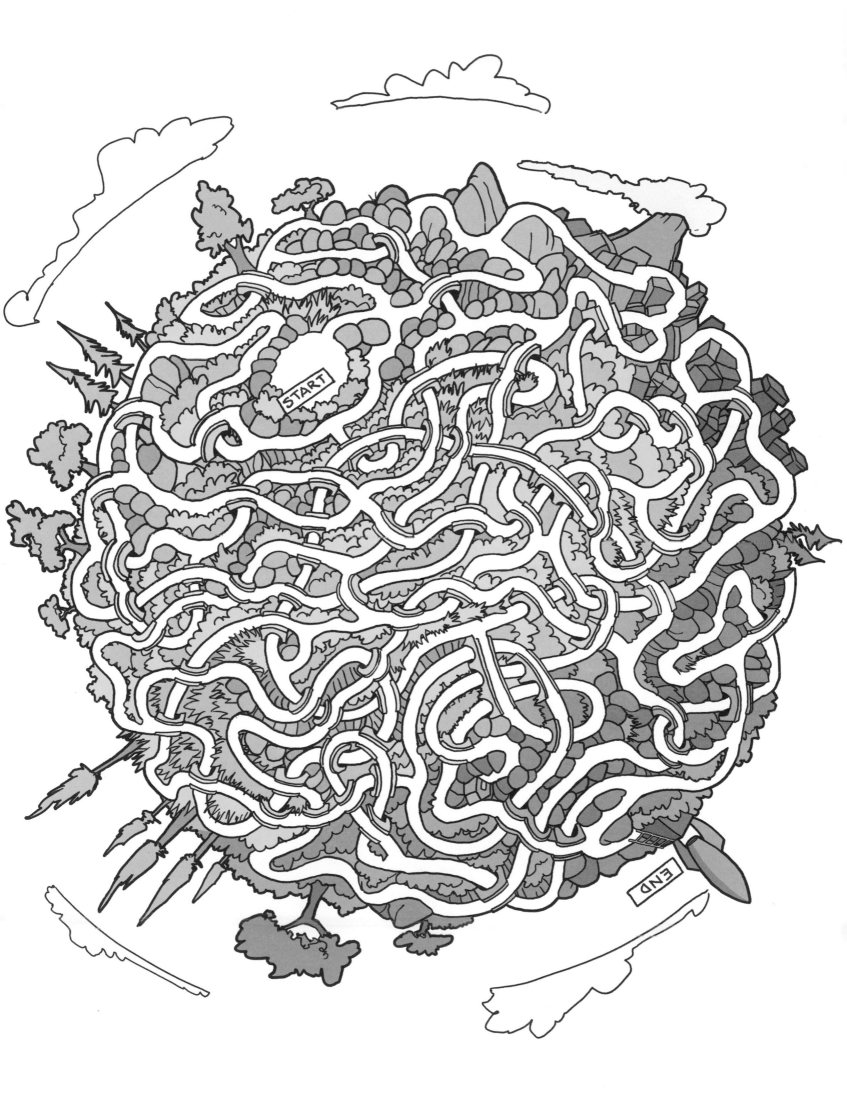

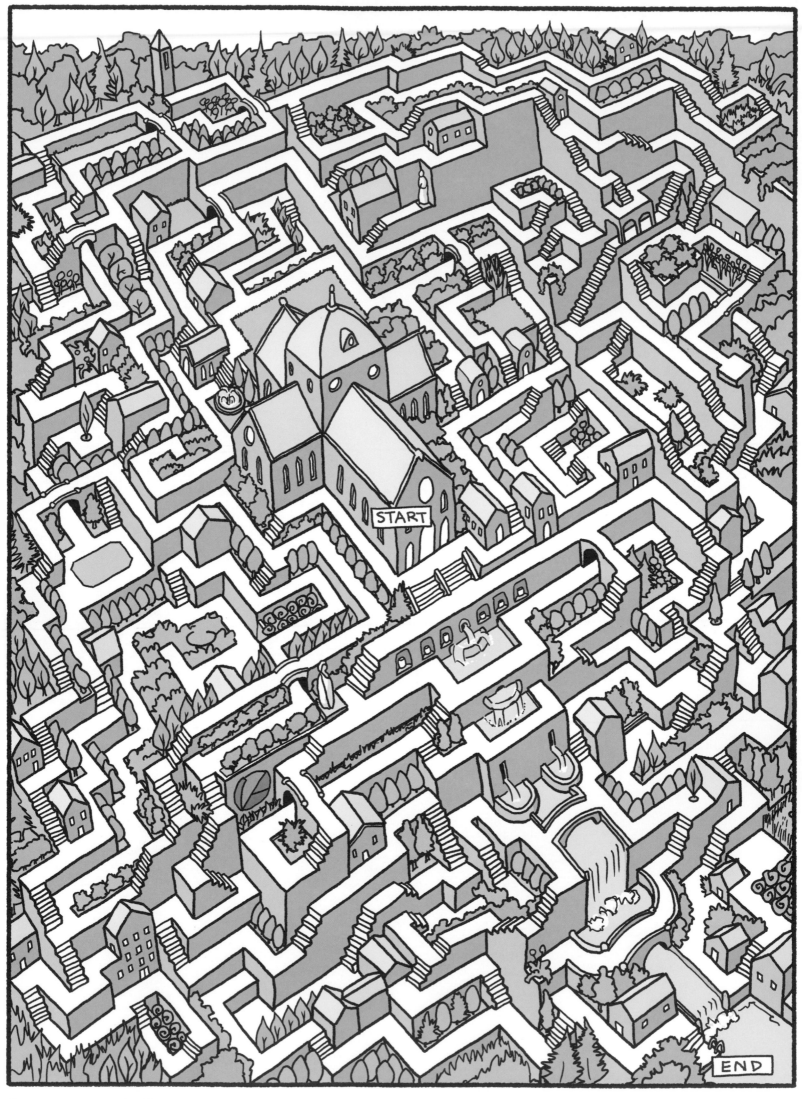

START

END

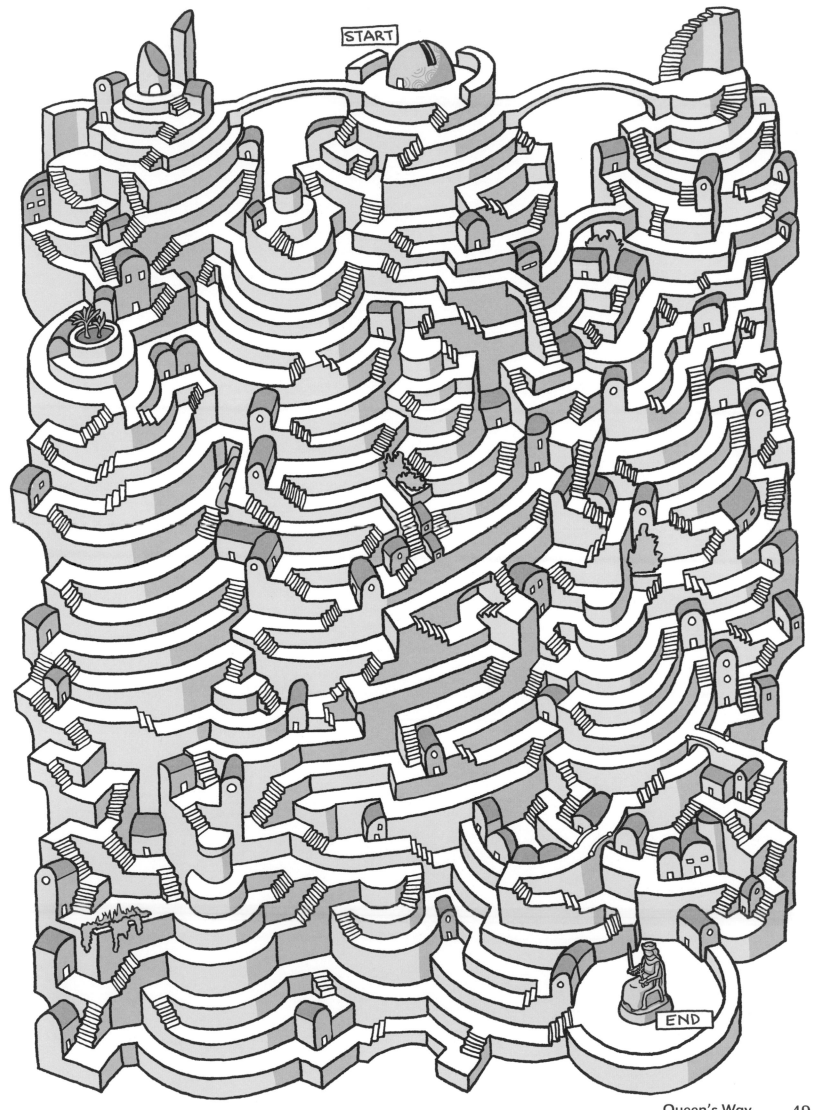

START

END

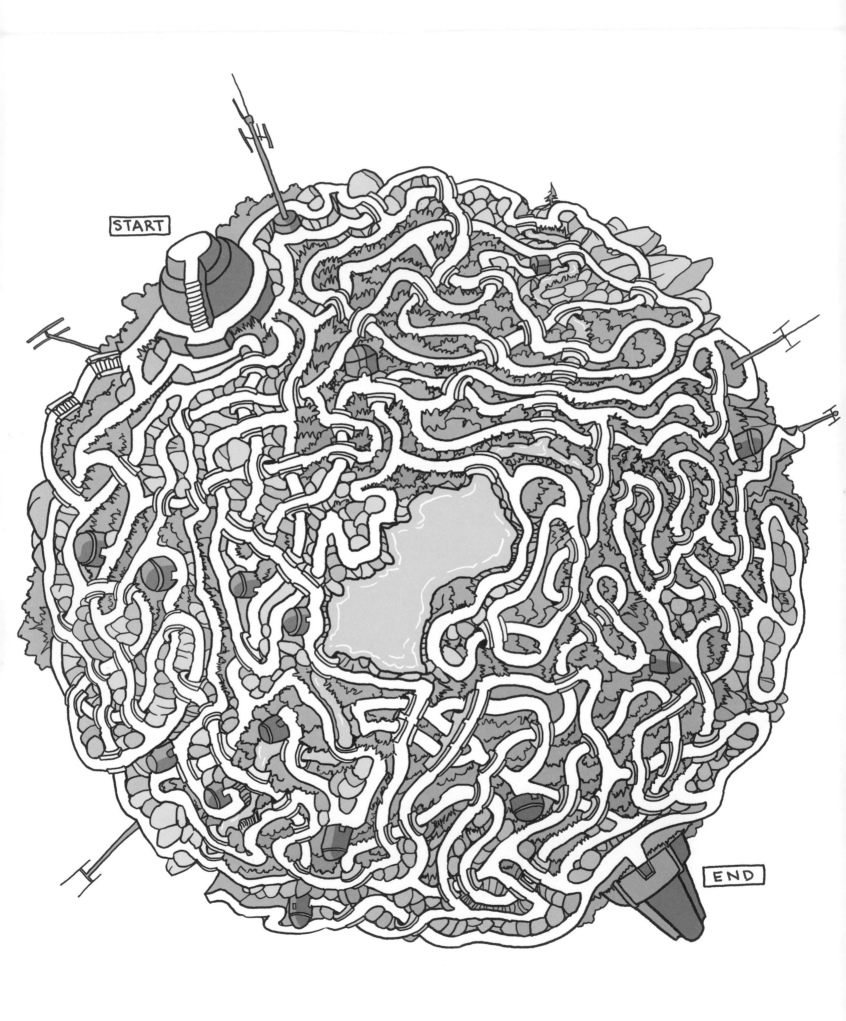

START

END

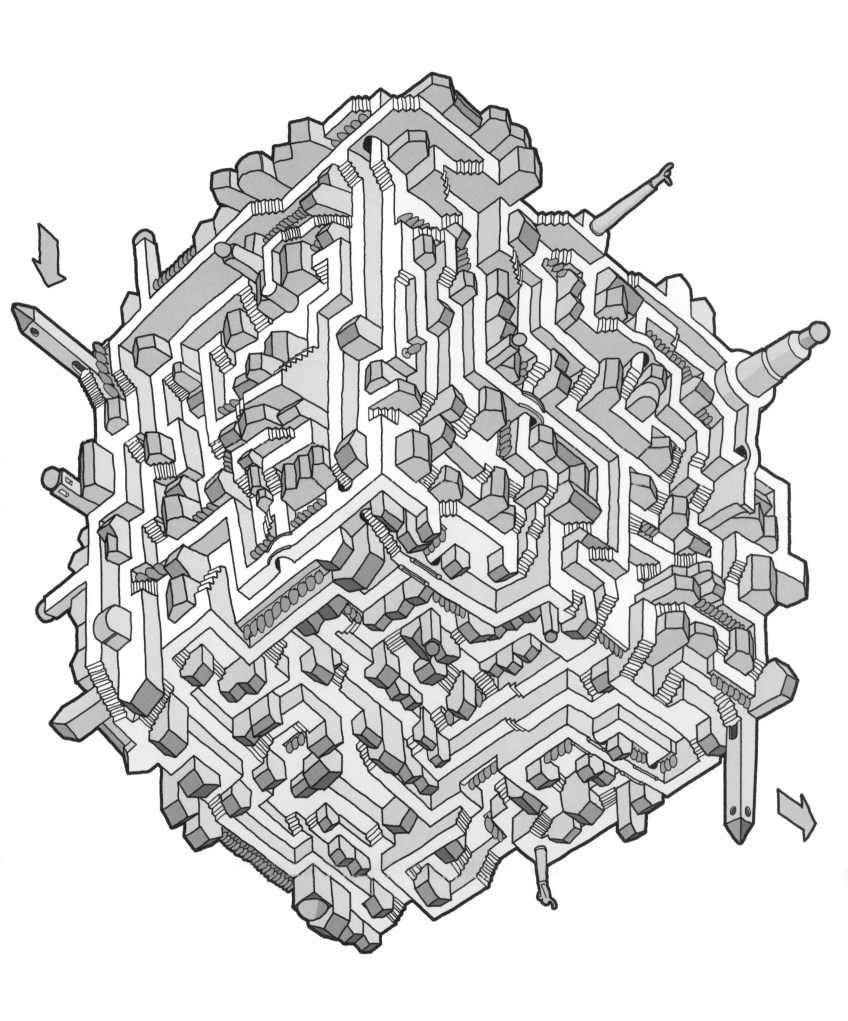

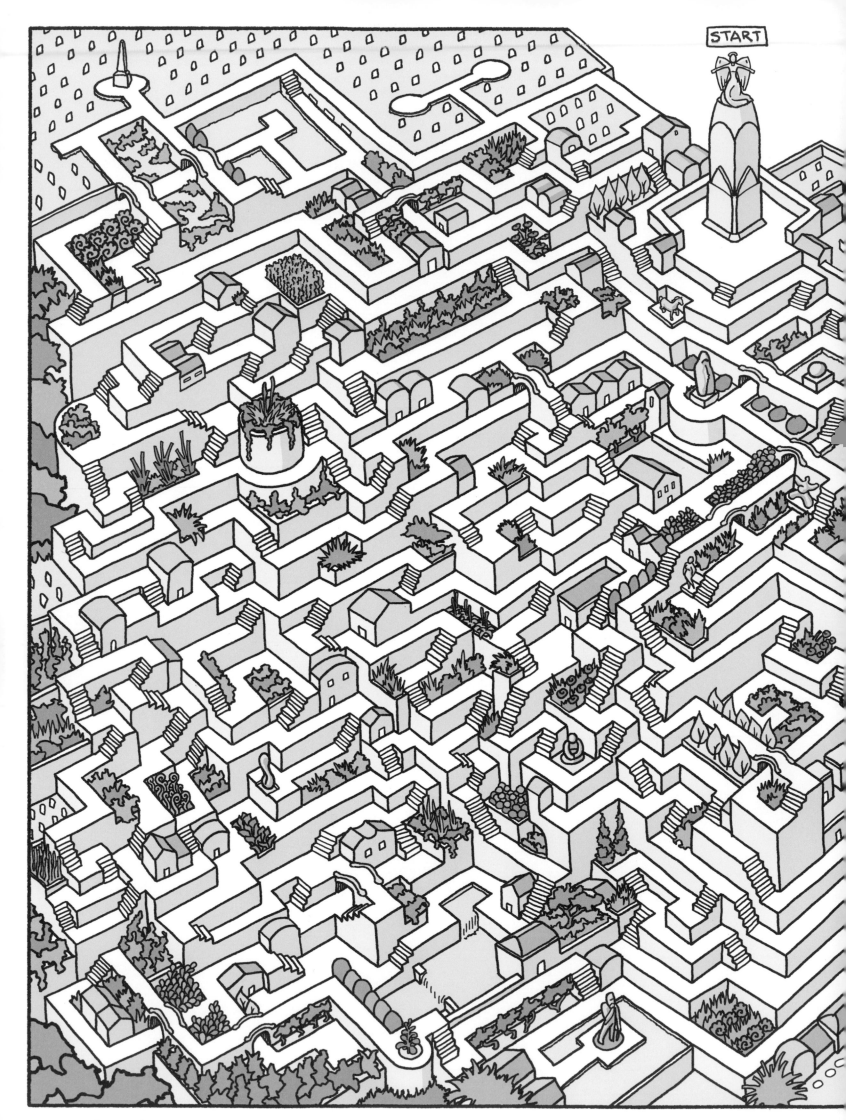

START

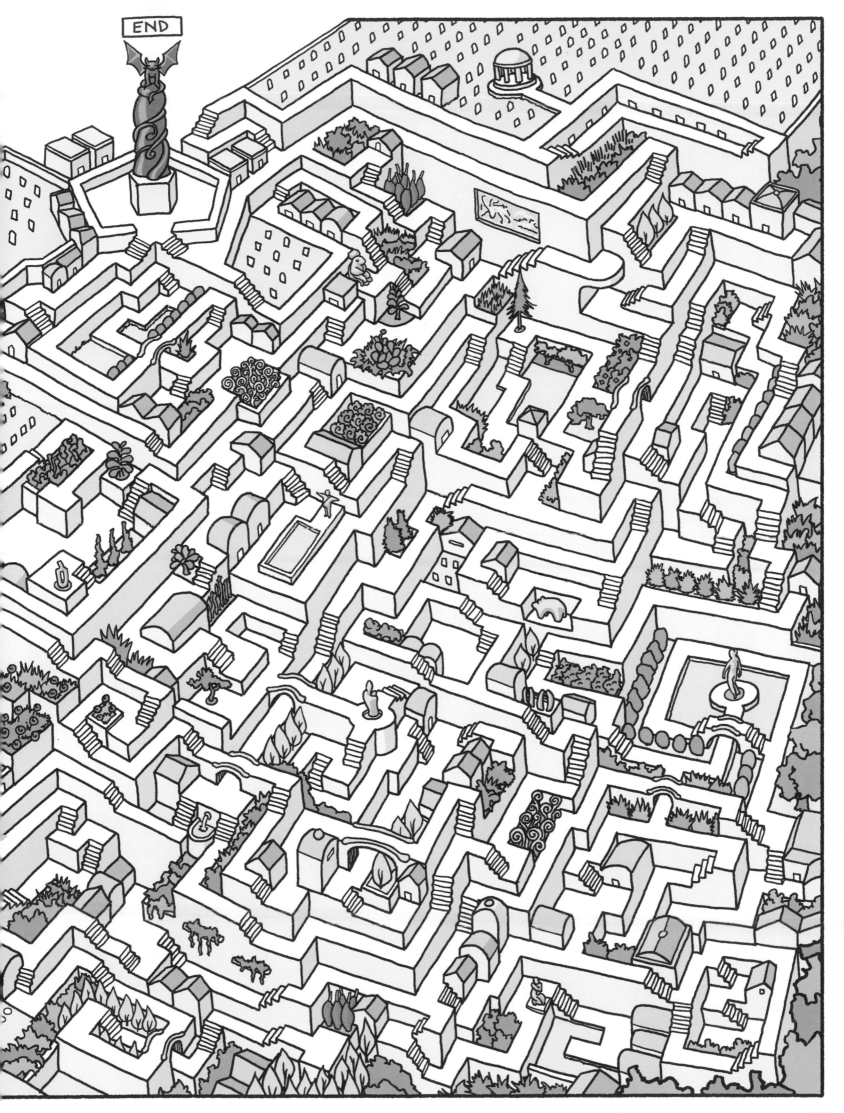

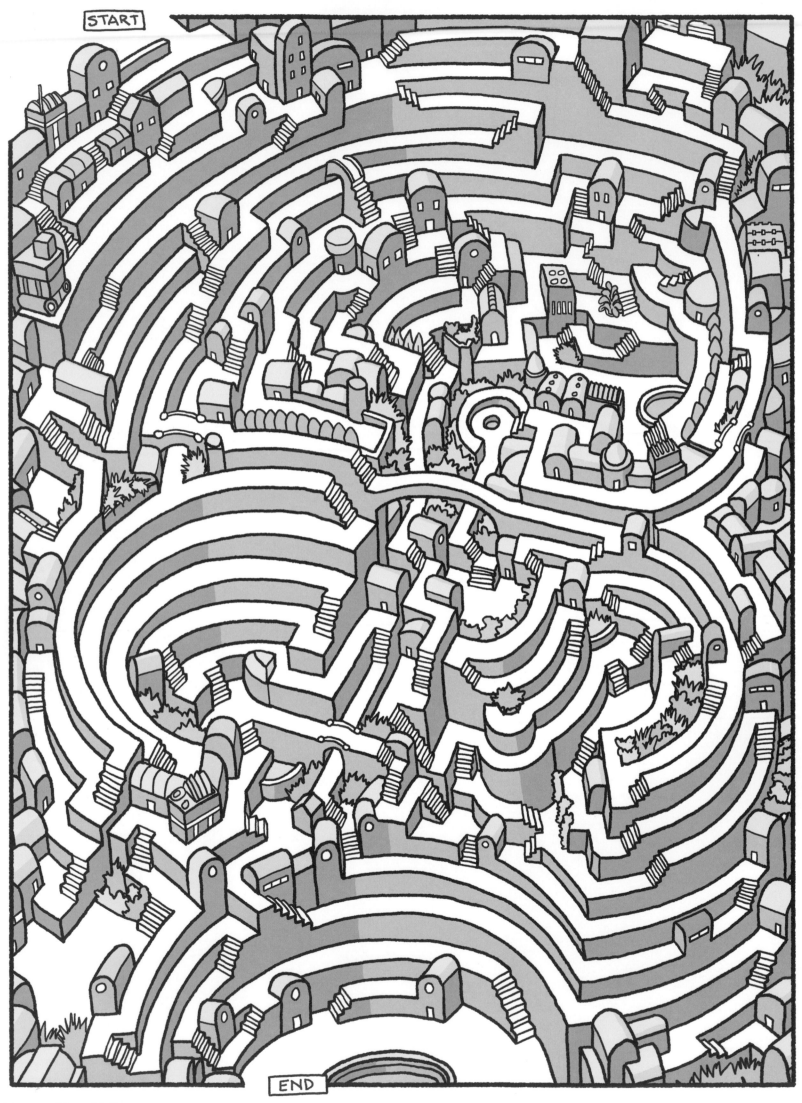

START

END

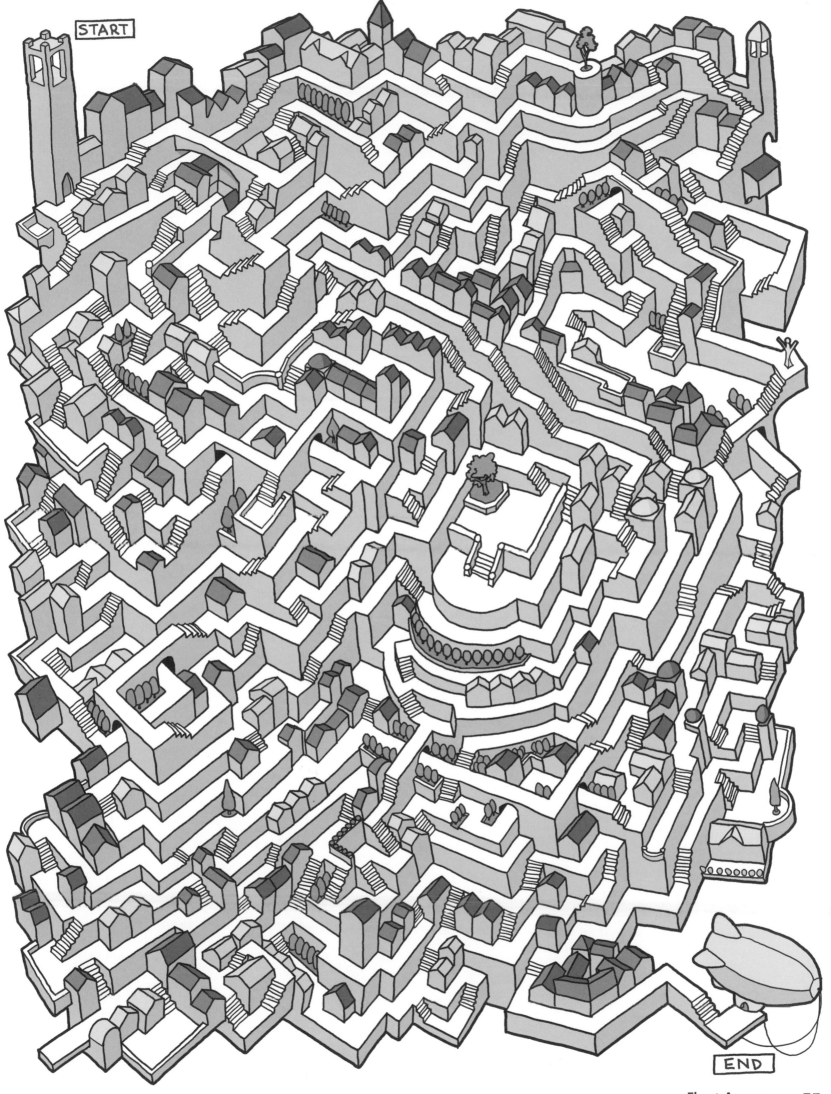

START

END

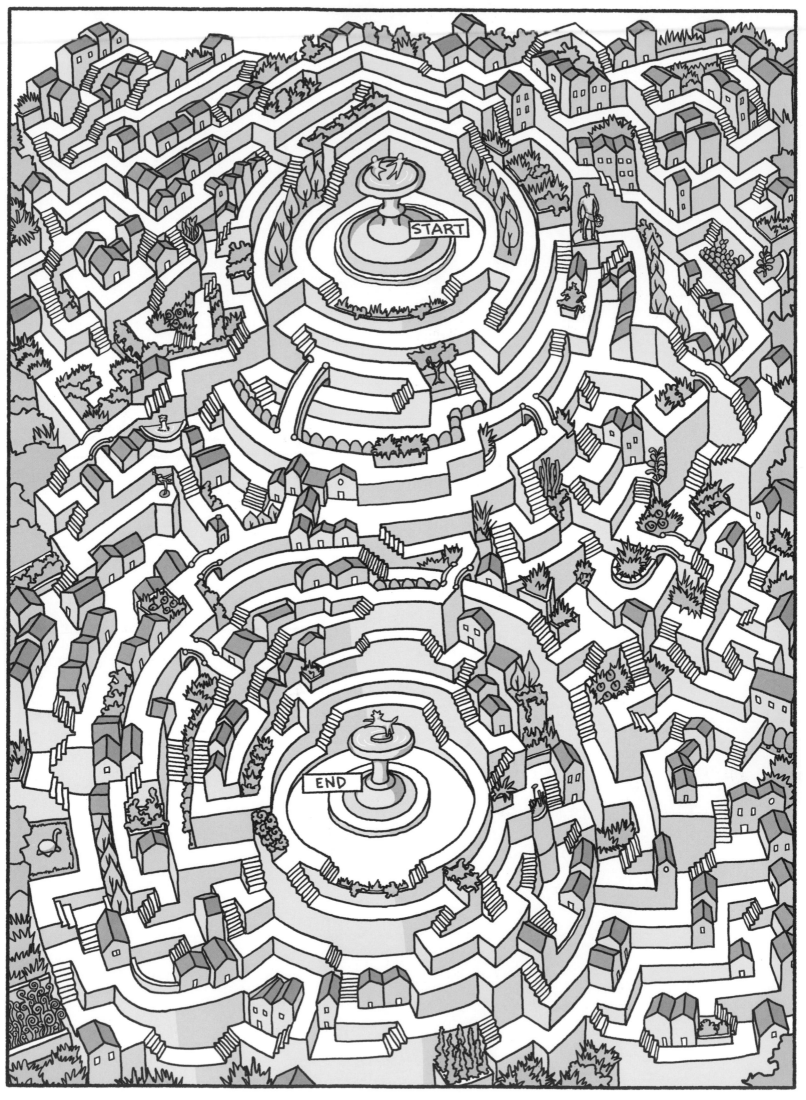

START

END

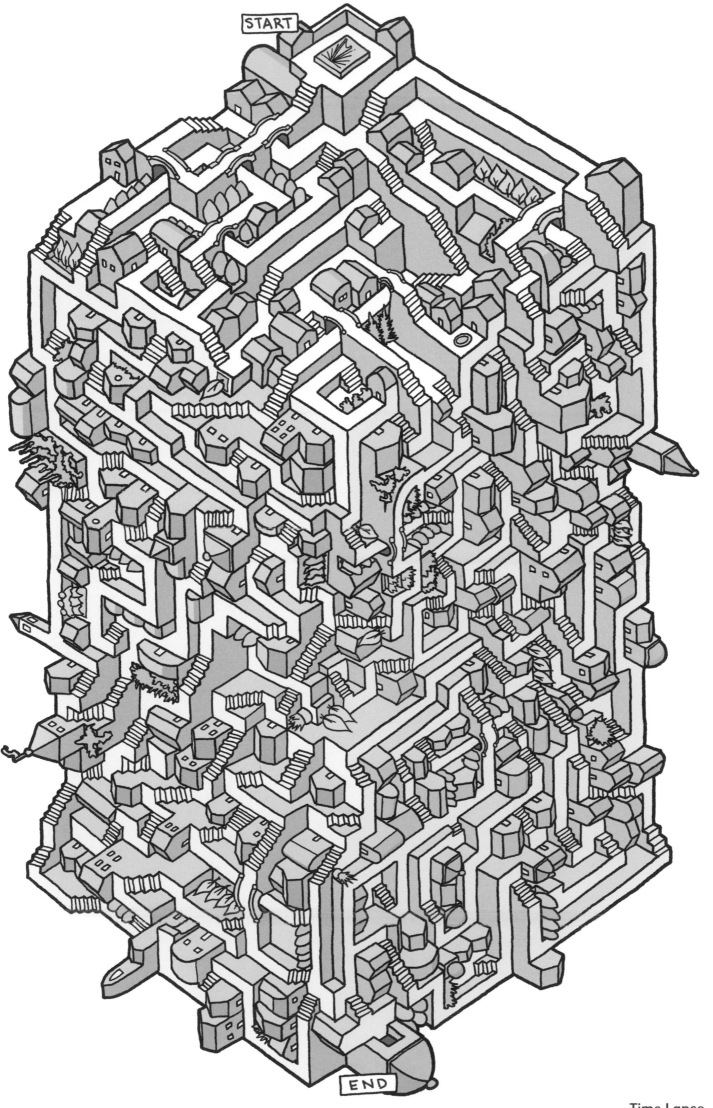

START

END

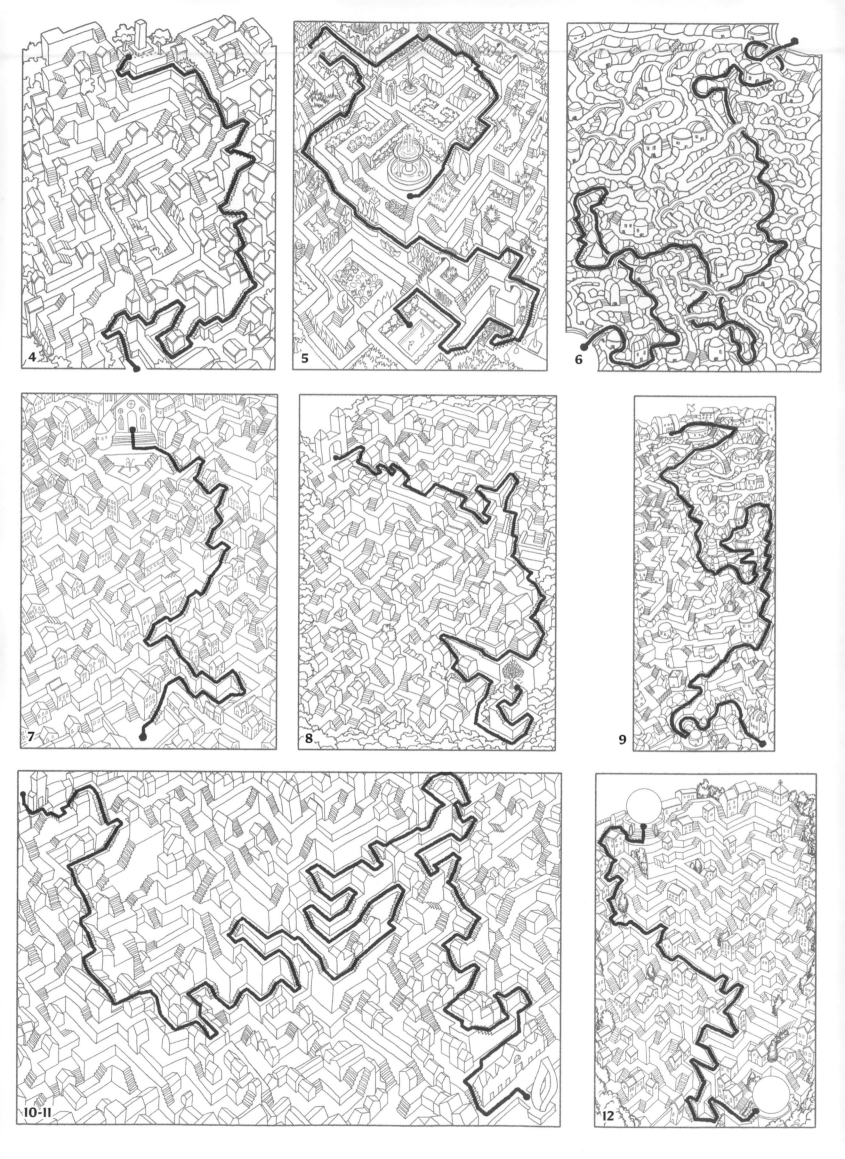

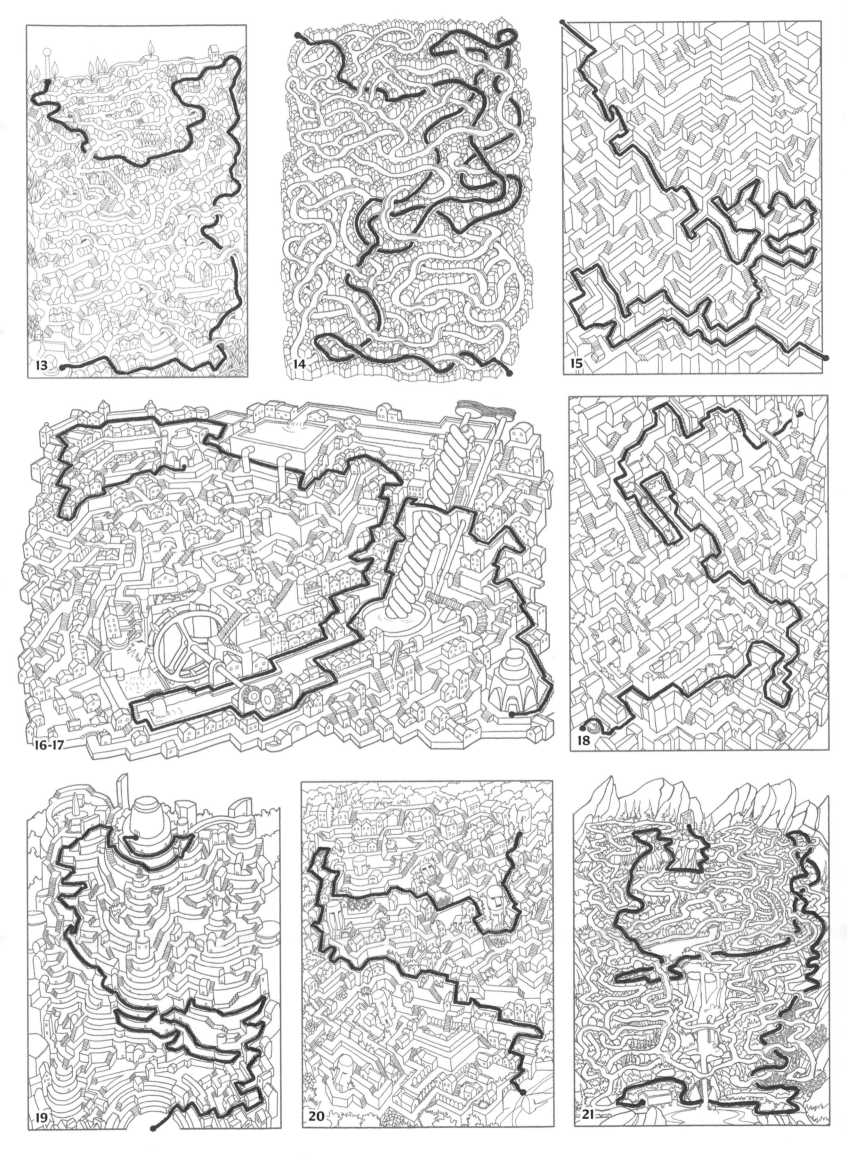

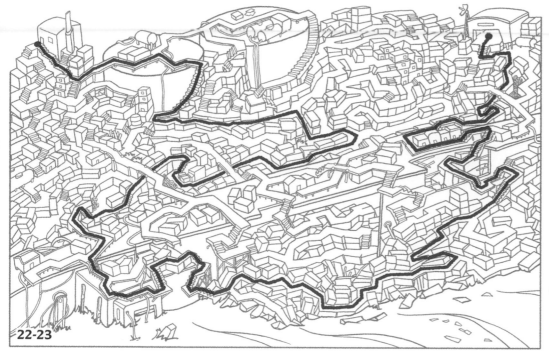

22-23

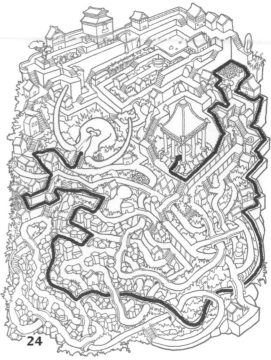

24

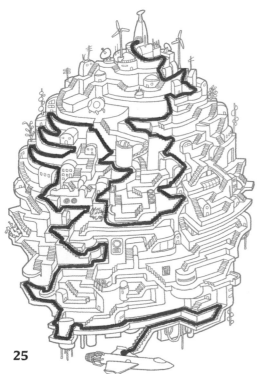

25

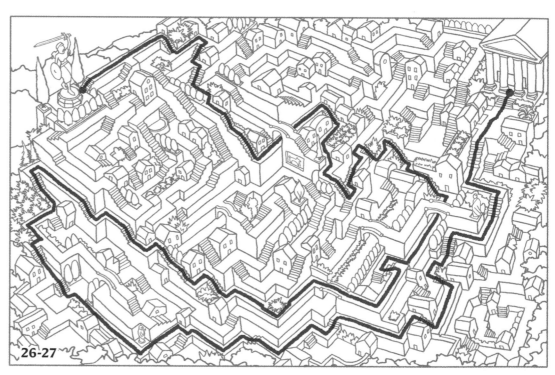

26-27

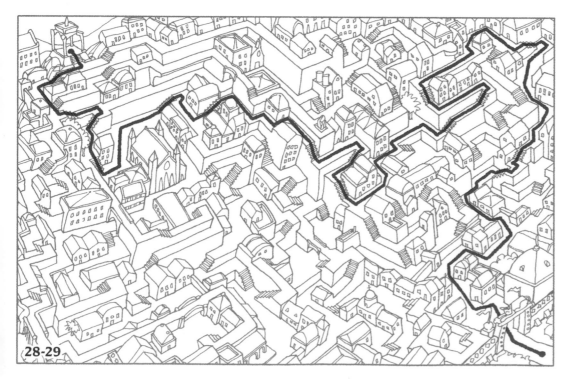

28-29

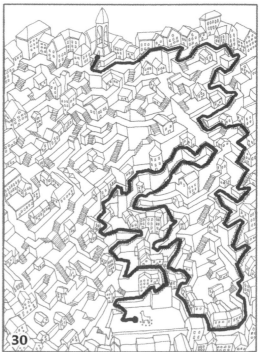

30

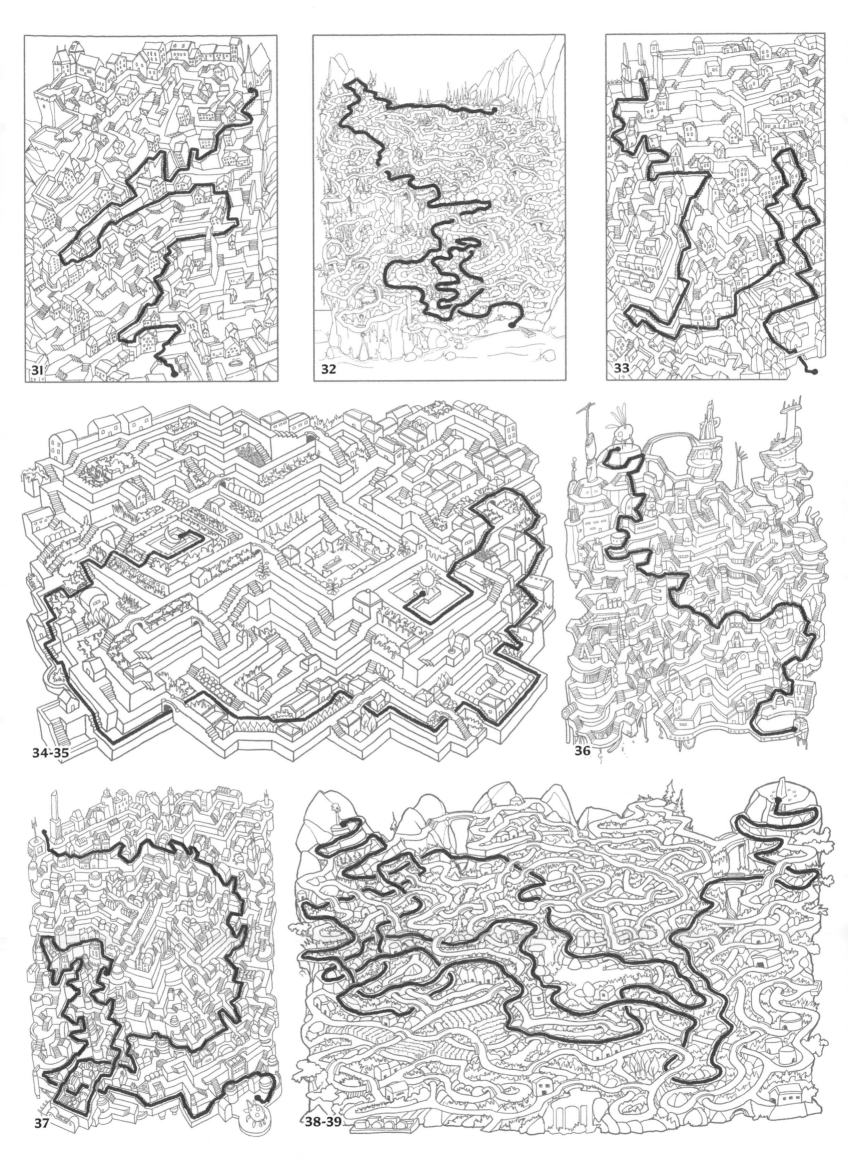

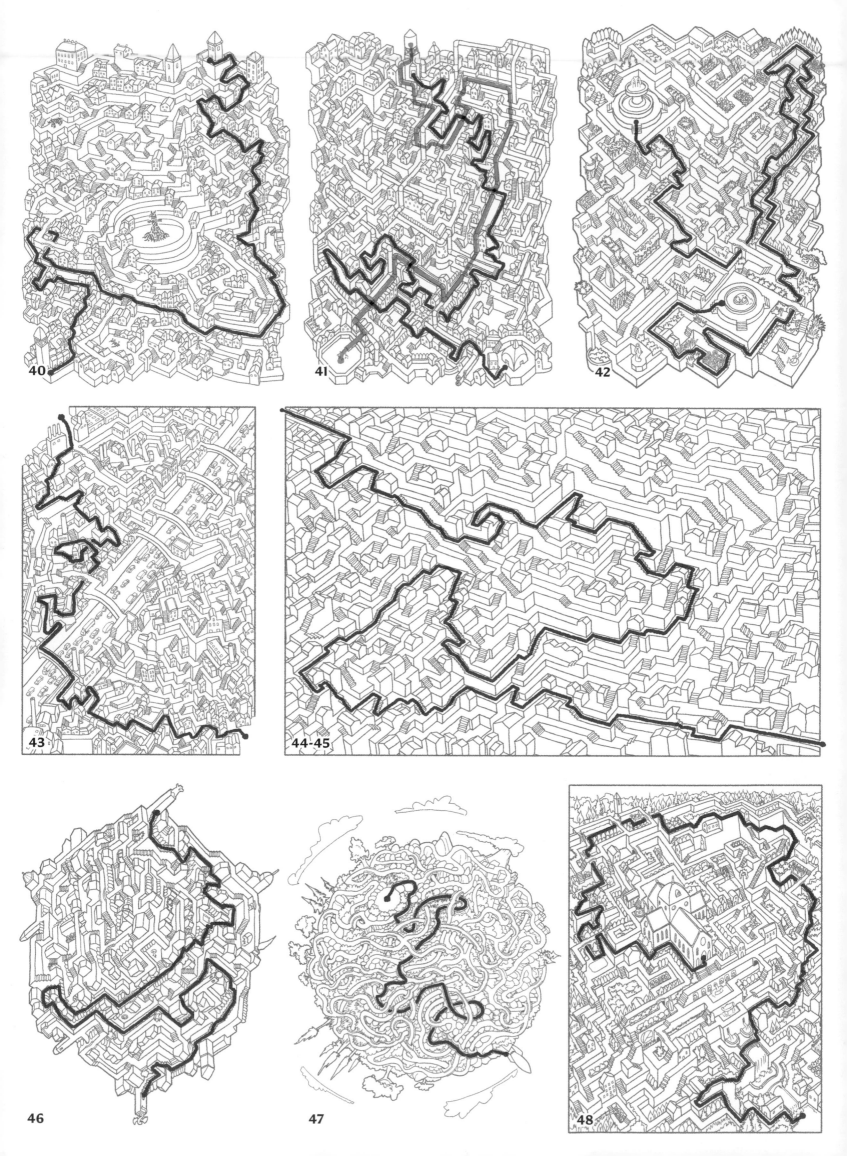

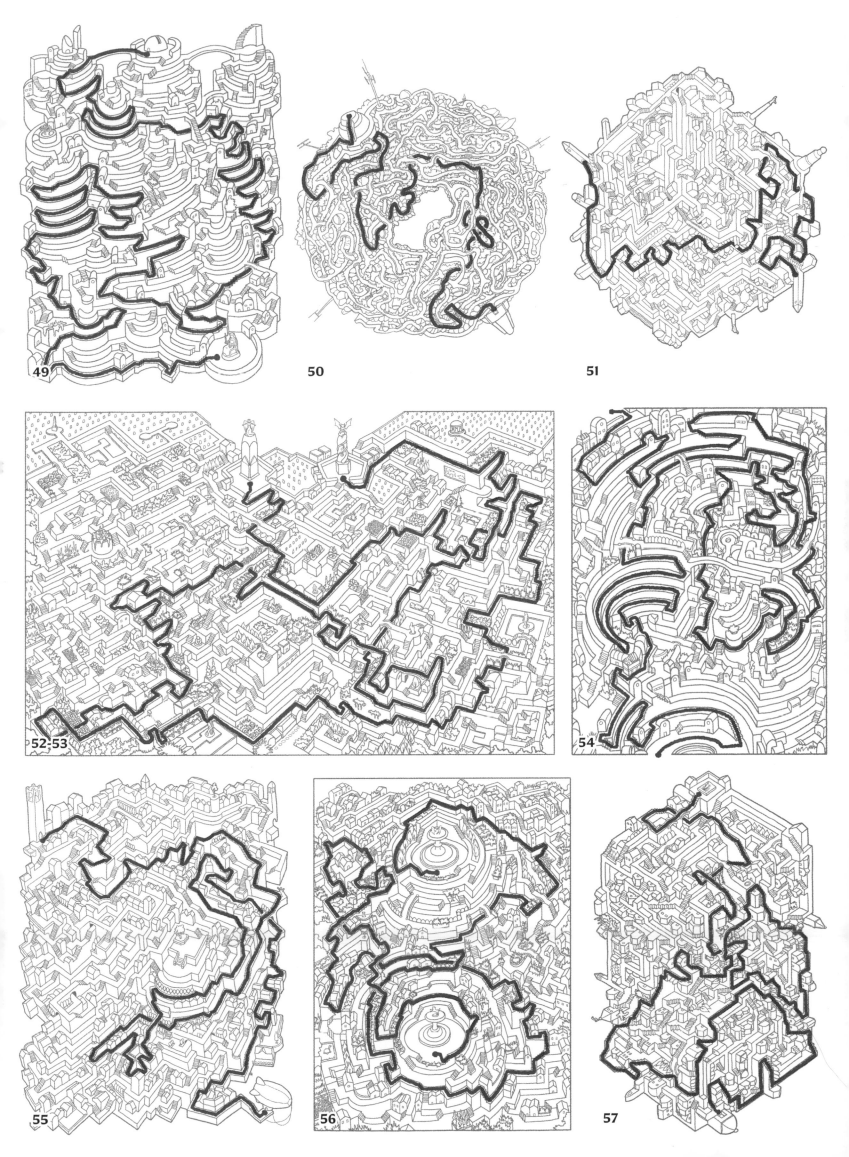

About the Author

Sean C. Jackson is a broadcast designer and art director based in New York. His daily work is in the high pressure, deadline oriented field of network news. By shutting down the monitors and creating with pencil and paper, pen and ink, he can power down from the fast paced world of the newsroom. He has been creating mazes for his personal enjoyment and relaxation for more than 30 years. This is his first book.

Photograph by Haley Ballard

Some Notes On The Mazes

5 Garden Path: For me, the garden mazes are the most realistic spaces. I experiment with styles of plants and sculptures and often include artists I like such as Alexander Calder, Henry Moore, or Arnaldo Pomodoro.

6 Rocky Road: Path mazes are more about winding through landscapes and often include many bridges. You can go under or over the bridges which are usually distinguished by color. **14 Klee Day:** Even before coloring, the tiny, repeating buildings reminded me of Paul Klee's city doodles. I chose colors that felt in step with his work.

16 The Water Wheel: The pipes are just decoration, but the water wheel really does move the gears to turn the giant water screw.

20 New World Now: This is an attempt to capture the marvel we feel for the giant and ancient artifacts of our ancestors. The paths and buildings are vaguely colonial and have to bend and concede to the stone giants, and the jungle wants to engulf everything.

22 Shipbreaker: This grew from wanting to make a maze of shipping containers with lovely industrial colors and simple repetitive shapes. I also wanted to explore junkyards, with the exciting tension between stacked order and natural disorder. The name comes from the Paolo Bacigalupi novel, which focuses on the survival of civilization on the skeleton of the 21st century after massive sea level rise.

24 Remembered: I wanted try classical Japanese inspired structures with a natural path environment. The building at top was inspired by the bathhouse from *Spirited Away*. The elephant skull is just a bonus. **25 Orbital:** A high atmosphere work station and living quarters. **26 Temple of Enyo:** I was imagining a classical style garden, where philosophers would stroll in a Roman period movie.

28 South Gate: The creature at the end gate is a dragon. I know it looks like a big cat, but I like to think of it as a dragon. **30 Llama Lawn:** An earlier maze, in which the city feels slightly more structured. Once I had discovered these colors in combination, I continued to use them often in later work.

31 Hayride: The earliest maze in the collection, drawn in 1999. This was the first maze I created that was more than just youthful doodling. **33 The Golden Hour:** This older maze has always felt like a desert city to me, and so I think of the desert planet Arrakis in Frank Herbert's *Dune*.

40 Harvest Moon: The bonfires sprinkled about the city are inspired by the anime *Spice and Wolf*, introduced to me by my daughter. I was excited to play with the buildings casting shadows upon one another.

41 Down Pipe and Path: Both the path and the pipe start at the water tower. You can follow each to its own solution. **42 The Golden Frog:** Is that a Richard Serra? Yes, it is. **46 Bear Block:** The cubes are definitely the work most influenced by M.C. Escher. Each side has its own up and down, and staircases take you from one side to another. Some may find it helpful to rotate the book to solve.

47 Blue Rocket: I was recalling the Maxis game *Spore* when deciding to wrap one of my path mazes around a sphere, like a little planet. **48 Down to the Water:** The cathedral is loosely based on St. John the Divine in New York City. The waterfalls lead to a baptismal at the end.

52 A Quiet Place: This is the most complex garden in the book. Statues inspired by Joan Miró, Hieronymus Bosch, and others are sprinkled about. **56 Jack and Jill:** Two interlocking terraces for twice the fun. **57 Time Lapse:** A larger cube maze, it is intended to be much harder. Enjoy!